IMAGES
of America

EAST AMWELL

ON THE COVER: A steam train chugs into the Ringoes Railroad Station. The railroad first pulled into Ringoes in 1854, changing the town overnight. The rail yards became a commercial center, housing a mattress factory, feed mill, lumberyard, and dairy transfer station over the years. Here the buildings of a tomato canning factory are visible on the left. (Courtesy of East Amwell Township, Edward Quick Collection.)

IMAGES
of America

EAST AMWELL

East Amwell Historical Society

ARCADIA
PUBLISHING

Published by Arcadia Publishing
Charleston SC, Chicago IL, Portsmouth NH, San Francisco CA

Printed in the United States of America

Library of Congress Control Number: 2009943731

For all general information contact Arcadia Publishing at:
Telephone 843-853-2070
Fax 843-853-0044
E-mail sales@arcadiapublishing.com
For customer service and orders:
Toll-Free 1-888-313-2665

Visit us on the Internet at www.arcadiapublishing.com

To Edward Quick: Thanks for the memories.

CONTENTS

ACKNOWLEDGMENTS

We wish to express our sincere gratitude to everyone who contributed photographs: Teri C. Angelone, Harriet Barrick, Andrew Beck, Elizabeth A. Bernhard, Betty Jane Biache, Betty A. Bollin, David Bond, Jani Collins, Charles Conover, Anthony Q. Culver, Charles E. Danberry, Alberta Flagg, Charles Fisher, Irma Fuhr, Frederick and Gael Gardner, Margaret H. Gritzmacher, William and Barbara Harrison, Irvin Hockenbury, John and Marilyn Kanach, Louise Kenney, Kirkpatrick Presbyterian Church, Paul Kurzenberger, John and Carol LePree, Linda R. Marshall, Deborah Lentine, Linvale Methodist Church, Roger L. Paffitt, Janet Palmieri, Sue Posselt, Ellen Ramberg, Roger H. Reiter, William Reiter, Glorianne Robbi, Doris E. Snyder, Joe and Bernice Sowsian, Jeffrey D. Titus, June Totten, Hermione Van Doren, Kathy and Todd Wagner of Hillbilly Hall, Ronald Wielenta, and Doris Wilcox. The Hunterdon County Historical Society, the Amwell Valley-Ringoes Rescue Squad, and Mark Falzini of the New Jersey State Police Museum also graciously shared images for this volume. We want to offer a special thank you to Grace Cronce, who not only shared photographs, but also took the time to answer so many questions about our community.

Our editor at Arcadia, Erin Rocha, deserves our thanks for her tireless support and feedback over the past several months. Finally we are grateful to the East Amwell Township Committee and all of the members of the East Amwell Township Historic Preservation Committee for their support in this project.

All photographs not otherwise credited come from the East Amwell Township Historic Preservation Committee, Edward Quick Collection.

—Kat Cannelongo, Jim Davidson, Jennifer Floyd, Dave Harding, and Paul Sterchele

INTRODUCTION

When John Ringo arrived in the wooded lands that one day would bear his name, he was hauling a treasure chest and looking over his shoulder. Born in 1655 at Fort Beversreede, New York, Ringo set sail to Spain where pirates kidnapped him. He escaped and returned to America laden with a chest of loot, according to legend. Fearing pirate retaliation, he hacked his way through the New Jersey wilderness before building a log cabin in 1720 near the crossroads of two Native American footpaths. Ringo supposedly buried his treasure, which has never been found.

Ringo had few neighbors in the Amwell Valley upon his arrival. The Unanus tribe of the Leni Lenape Indians resided in a scattering of villages such as Wishelemensey on the Malayelick Trail near present-day Rocktown Road. Several wealthy landowners held large tracts, which they sold piecemeal to settlers. Settlements began sprouting along the length of the Nariticong Trail, which became the King's Highway then Old York Road. While the settlers and Leni Lenape apparently co-existed peacefully, the population spike compelled the wild game to move. Many Native Americans migrated west to follow the food. Among the few that remained, some perished from unfamiliar illnesses brought by the settlers.

Starting in the 1760s, Ringoes village became a hotbed of revolutionary activity. Sons of Liberty throughout the region gathered at Ringo's Tavern (operated by another John Ringo, the grandson of the founder) to harangue the British government for the Stamp Act. When the shouting stopped and the shooting started, a squad of citizen soldiers known as the Amwell Militia attacked a British party returning from Flemington following a raid on supplies of salted pork. Led by Capt. John Schenck, the militia ambushed a patrol of 20 horsemen in December 1776, shooting their leader Cornet Francis Geary in the head and killing him. The militia also earned plaudits for aiding Gen. George Washington's Christmas night crossing of the Delaware River by hiding Durham boats (large, flat-bottomed boats used on the river) behind Bull's Island.

Numerous Amwell citizens also shouldered muskets in the Continental Army. One such soldier was Jacob Francis. Born a slave in Amwell in 1754, Francis served five masters before gaining his freedom at age 21. He joined the army in Massachusetts and participated in the siege of Boston, which led to the British evacuation of the city. Francis later endured the long retreat through New Jersey before fighting in the Battle of Trenton and helping ferry Hessian prisoners across the Delaware following the victory. The following year, Hessian troops captured Francis, but he escaped the same day. After the war, he returned to Amwell and died in Flemington on July 20, 1836.

The war may have disrupted lives in the Amwell Valley, but progress rolled on nonetheless. The Swift-Sure stagecoach whipped along the Old York Road and slashed the travel time from Philadelphia to New York to two days. The cost for a one-way trip between cities was $3.50. The settlements along the road, traditionally referred to as hamlets, grew in prosperity once the war ended. The 18th-century Manner's Tavern settlement grew into Greenville (later Reaville) and rivaled Ringoes in size and stature, boasting a popular tavern, a church, a creamery, and several homes. Larison's Corner featured one of the most popular taverns in all of Hunterdon County; young

adults would drink and dance downstairs, and gamblers would win and lose fortunes upstairs. While some taverns flourished, one famous establishment disappeared from the landscape. After passing to several different owners, Ringo's Tavern burned to the ground on April 16, 1840. The *New Jersey State Gazette* reported: "The fire broke out in the hay in an adjoining shed about 8 o'clock, and no doubt is entertained that it was set on fire." A new tavern was built near the site, but the whereabouts of the sign that hung above the door with General Washington's portrait remain a mystery.

Almost 70 years later, the Ringoes Grange Meeting Hall opened down the street from the former tavern site to protect the interests of farmers in Amwell. This was a critical development because throughout the 1800s and for a significant part of the 1900s, agriculture was a vital industry in the township, with most residents laboring on family farms. Through the years the arrival of the railroad and improved agricultural machinery and farming methods helped put more coins in the farmers' pockets.

Ringoes gained recognition as an education center during the 1800s first with the opening of the Amwell Academy; students traveled from as far away as Baltimore to study there. The academy's doors closed in the 1830s, only to be reopened by Dr. Cornelius W. Larison and his brother. Cornelius Larison was renowned as a natural scientist, author of numerous books and a leading proponent of the simplified spelling movement of the late 19th century.

The boundaries of what became East Amwell Township were revised several times. Established in 1708 by a royal patent of Queen Anne, Amwell Township initially comprised 130,000 acres—about half of present-day Hunterdon County. While it had been partitioned in the past, Amwell was cleaved in 1846 to form East and West Amwell Townships. In 1854 and 1897, lands were added from Delaware, Raritan, and West Amwell Townships, and a revision of the boundary with West Amwell finalized the geographic layout of East Amwell in the 1950s.

East Amwell captured the world's attention in 1932 when the infant son of Charles Lindbergh and Anne Morrow Lindbergh was kidnapped from the family home in the Sourland Mountains. Police, reporters, and even a few celebrities descended on this bucolic community as the baby's decomposed body was discovered in neighboring Hopewell. After an intense manhunt, Bruno Hauptmann was arrested, tried, and executed for the crime.

To this day, history lives in East Amwell. One can drive through the village of Ringoes and see the stone Landis House where the Marquis de Lafayette convalesced during the American Revolution or rumble along the Old York Road like the stagecoaches of bygone days and be captivated by rolling hills, fertile fields, and 200-year-old farmhouses dotting the landscape.

One

THE SOURLANDS

Until recently, East Amwell's Sourland Mountains region was widely reputed to be a rough, dangerous, and inhospitable place. The first road cut over the mountain was Rileyville Road, opened in 1750; Amwell Road, now called Lindbergh, followed in 1770. The British avoided the treacherous Sourlands during the Revolutionary War, which led Declaration of Independence signer John Hart to hide in a cave off Lindbergh Road during the winter of 1777–1778.

Put's Tavern, operated by the manumitted slave Harry Compton in the early 1800s, lured clients from as far as New York and Philadelphia to the depths of the Sourland forests. This remote and risqué establishment was infamous for its debauchery. By the late 1800s, most of the trees had been cleared, and the mountain was used for extensive apple and peach orchards, as well as notorious moonshine stills. Disappearances and murders were common, and in the 1920s and 1930s, the area became known as a Mafia dumping ground for bodies.

The Sourlands were home to a diverse population, including a large African American community centered in Minnietown. This village behind Hillbilly Hall consisted of 23 houses, stores, and a post office, although none of these buildings remain. There was also a black church on Zion Road. Most of Minnietown's residents found work first as quarrymen for the stone quarries and later as basket makers for the large orchards.

The area became well known to the outside world in 1930, when Charles Lindbergh purchased 425 acres in the Sourlands and built Highfields, the home from which his son was kidnapped in 1932. Police and volunteers scoured the mountain until his son's body was found nearby. This led to the "trial of the century" in Flemington in 1935.

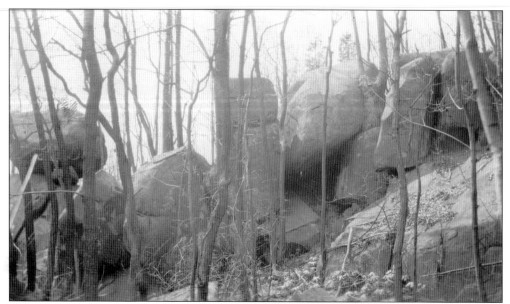

Caves and memorable formations are scattered throughout the rocky Sourlands. John Hart fled for his life when the British put a price on his head during the American Revolution. As the British ransacked his Hopewell home, Hart secreted himself in the Sourlands, spending the severe winter of 1777–1778 in this cave, which now bears his name. (Courtesy of Alberta Flagg.)

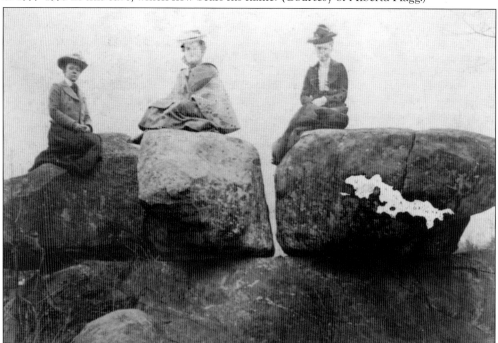

Another local Revolutionary haunts Knitting Betty Rock. Betty Wert spent days knitting on the rock, awaiting her fiancé's return from battle. Enraged by his death, she became a spy, but British troops captured and beheaded her. Many have seen her sometimes-headless ghost, knitting and pining for her love. Pictured above, three well-heeled ladies perch on another unusual rock formation, "Three Brothers," around 1890. (Courtesy of Alberta Flagg.)

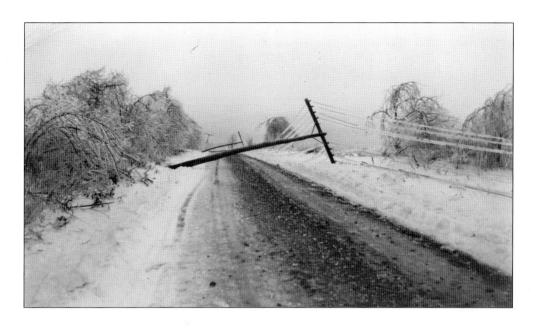

Electricity came to some houses on top of the Sourlands in the mid-1930s, but that did not mean it was on for long. The winters were cold, and the snows were deep. The photograph above shows the first Sourland Mountain power lines shortly after installation. Lindbergh Road, at the time known as Amwell Road, was widened by the Works Progress Administration during the Depression to help put the unemployed back to work. As the Depression worsened, many people lost their homes. The family shown below lived in this grass hut on the Sourlands during the summer. (Both courtesy of Alberta Flagg.)

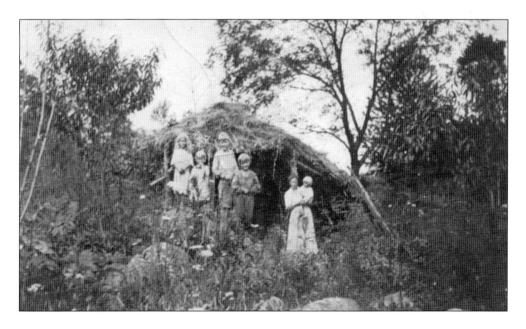

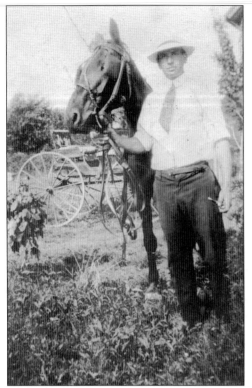

In the late 1800s and early 1900s, the Sourlands were farmed, with only the rockiest portions kept as woodlots. Andrew Hausenbauer moved from New York City in the early 1920s to help his father-in-law farm 88 acres with three horses. When not farming, Hausenbauer worked as a baker in Hopewell. He is shown to the left with his horse-and-buggy getting ready to ride into Hopewell to work. Hausenbauer was also an active beekeeper. He had hives all over the Amwell Valley and as far away as Princeton. Hives were placed in different fields such as clover or buckwheat, yielding honeys with distinctive flavors. He sold his honey out of his home to locals and bakeries throughout New Jersey. Pictured below, Hausenbauer relaxes with some of his hives in a field of daisies around 1935. (Both courtesy of Alberta Flagg.)

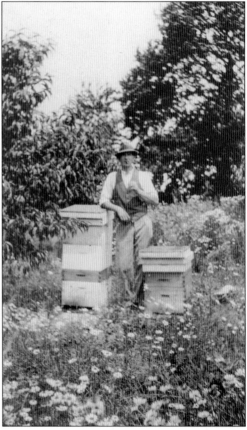

The blacksmith was one of the most important members of the community. Not only did he shoe horses and repair farm implements, he also manufactured and repaired household goods. Every town had at least one blacksmith; Ringoes had two. This 1904 photograph shows blacksmith Peter McDonald at his Sourlands shop. (Courtesy of Alberta Flagg.)

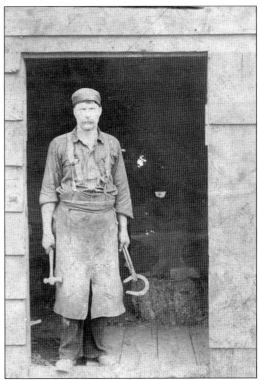

The Eick family is dressed in their finest for church, posing around 1920 on the porch of their Sourlands home. Although the area had a reputation for being rough and dangerous, by 1920, many families like the Eicks had settled there, establishing farms and orchards on the mountain despite rocky terrain. (Courtesy of Alberta Flagg.)

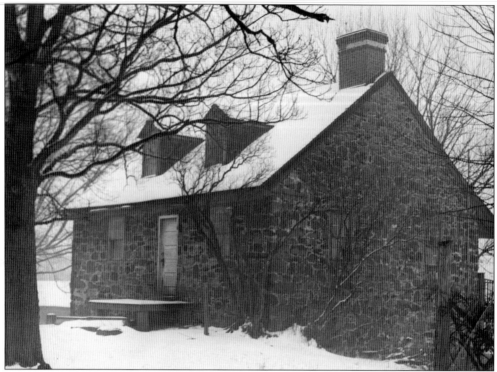

This 18th-century stone house was one of the oldest in East Amwell. It was located on the road from Allen's Corner to Buttonwood Corner, which is now the blocked North Hill and South Hill Roads. Originally known as the Van Doren house, it featured a massive walk-in stone fireplace, large exposed beams, and a rear wood staircase. Hand-carved stars adorned the wooden dormer windows. In the late 1940s, a spark from a pile of burning leaves blew onto the roof. It took the volunteer fire department half an hour to get to the remote house, and it was damaged beyond recovery. It is shown above before the fire and below after the extensive damage. (Above photograph courtesy of Frederick and Gael Gardner.)

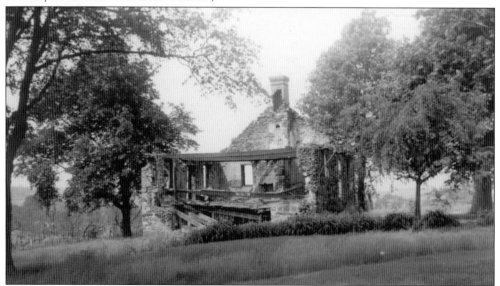

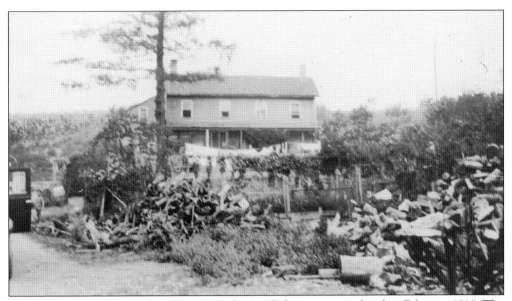

Richard Wyckoff and his housekeeper, Catherine Fisher, were murdered in February 1916. The murderers crushed Fisher's skull with an iron rod in a barn before entering this house and killing Wyckoff with an axe. Police hired the Burns Detective Agency, whose undercover agents spent three months on the mountain. They identified the murderers—and discovered nine other murders that had occurred in the previous seven years, within 1 mile of the Wyckoff farm! (Courtesy of Alberta Flagg.)

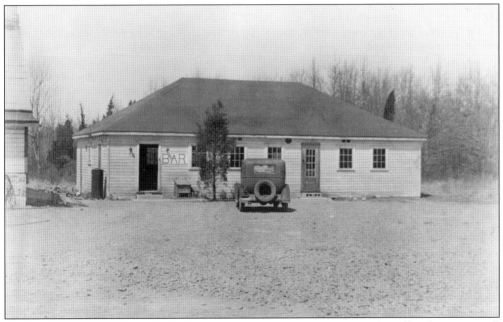

Hillbilly Hall is a legendary fixture in the Sourlands, on the border of Hopewell and East Amwell at the former site of Minnietown. Minnietown was a primarily black settlement with about 23 houses, a general store, and a post office. Many residents wove baskets for the Wyckoff peach orchards in Buttonwood Corners. When the peach blight hit in 1890, Minnietown faded; it was vacant by 1900. (Courtesy of Kathy and Todd Wagner from Hillbilly Hall.)

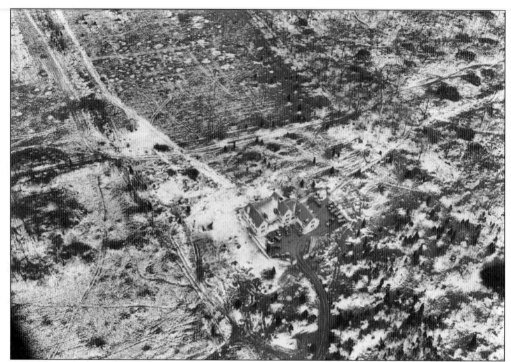

In 1930, Charles Lindbergh had a Princeton realtor quietly purchase 13 adjoining pieces of property to assemble his 425-acre estate, Highfields. This aerial picture was taken March 2, 1932, the day after his son Charles Jr. was kidnapped. Notice the rough airstrip at the top, and the lack of trees on the property due to the area having been heavily farmed. (Courtesy of the New Jersey State Police Museum.)

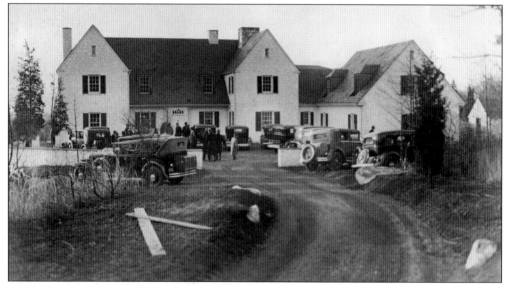

As soon as the Lindbergh baby was kidnapped, crowds began to gather. The next day an estimated 1,500 cars lined Amwell (Lindbergh) Road and the adjoining roads. Curious spectators trampled the grounds around the crime scene. State police headquarters were set up inside the Lindbergh garage on the right side of the house. (Courtesy of the New Jersey State Police Museum.)

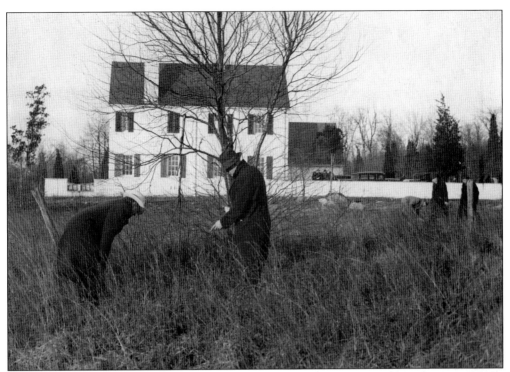

Investigators discovered only three clues outside the house: a three-section, broken ladder; a footprint at the base of the baby's window (from which a plaster cast was never made); and a wood chisel. Bruno Hauptmann, the man executed for the crime, was found to have a floorboard missing from his attic that matched a board on the ladder and one chisel missing from his tool chest. (Courtesy of the New Jersey State Police Museum.)

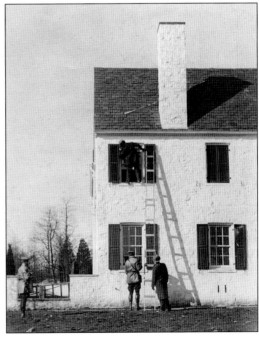

Police re-enact how the baby was probably kidnapped from his bedroom. The prevailing theory is that the ladder rail broke while the kidnapper was taking the baby out the window, causing the baby to drop to the flagstone walk below where he died instantly of head injuries. Six weeks after the kidnapping, the baby's body was found in the woods 4 miles away. (Courtesy of the New Jersey State Police Museum.)

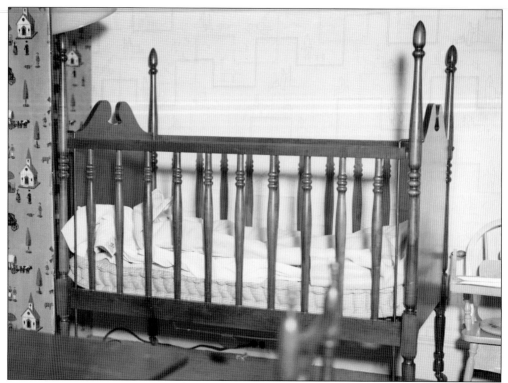

The Lindbergh baby was kidnapped from this crib. The kidnapper left a ransom note on a nearby dresser. Surprisingly there were no footprints on the bedroom floor even though it was raining and very muddy the night of the kidnapping. This encouraged theories that the kidnapping was an inside job. (Courtesy of the New Jersey State Police Museum.)

The Lindbergh's fox terrier, Wahgoosh, became important in the kidnapping investigation. Although the dog would bark at the slightest noise, he did not bark at all the night of the kidnapping. Along with the notable lack of muddy footprints, "the dog that did not bark" helped further encourage theories that the kidnapping was an inside job. (Courtesy of the New Jersey State Police Museum.)

Two

RINGOES

By 1800, Ringoes was a good-size town in Amwell, but it thrived once the railroad arrived in 1854. The railroad brought industry and vitality to the area. By 1889, Ringoes had a population of about 250. The town flourished with two churches, a post office, three general stores, a hotel, a pool room, a saloon, a barbershop, a tailor, a millinery shop, two shoe stores, a grain market and grain store, a pork and poultry market at the rail depot, a butcher, two blacksmith shops, a wheelwright, a harness shop, a hardware store, a tinker, a lumber and coal yard, a mattress factory, and a furniture store. Besides the influx of travelers and commerce, the railroad ignited a boom in residential construction. In 1900, the Pennsylvania Railroad built flagstone sidewalks, connecting the new houses and businesses in the center of town to the rail depot.

Ringoes continued to bustle and hum with activity well into the 20th century. However, after the new U.S. Route 202 and U.S. Route 31 bypass was built in the early 1960s, traffic no longer passed through the downtown. The passenger railroad closed. One by one, residents jumped in their cars to drive to new shopping centers being built around Flemington. Despite this economic shift, the downtown still boasts a pair of restaurants, two banks (one of which recently earned a historic preservation award), a library, and several other businesses. Other buildings that once served as stores became beloved homes for residents who savored the special ambiance of the village.

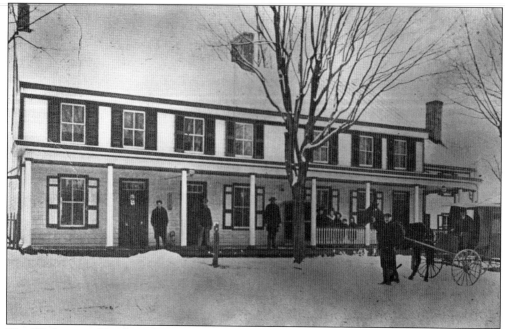

The Washington Hotel was built in 1851, a decade after Ringo's Tavern burned. Social activity swirled around the hotel and its broad veranda, and the Swift-Sure stagecoach stopped there three times a week. The hotel featured a restaurant, bar, and pool hall. It sent a livery to pick up passengers at the Ringoes Train Station, first with a horse-and-buggy and later a Model-T Ford.

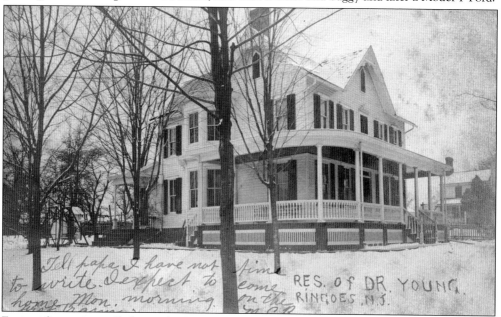

Four or five trains pulled into the Ringoes Station daily, bringing new business and travelers to town. After the railroad's arrival in 1854, newly prosperous residents built large Victorian-style houses. Dr. Peter Young owned one of the town's grandest residences, shown here. Later veterinarian William Harrison lived in the house now owned by the Miller family. (Courtesy of Margaret H. Gritzmacher.)

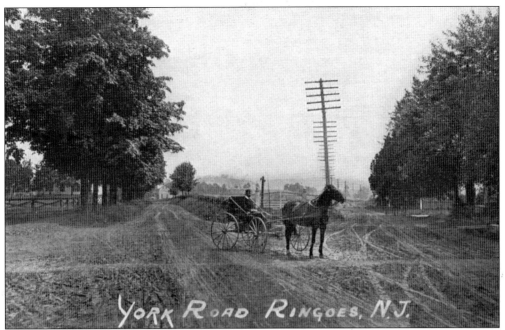

This view shows where U.S. Route 31 (left) and U.S. Route 179 merge into the Old York Road in the center of Ringoes before 1900, when both were still dirt roads. Over the years, many businesses operated at "the Point" including a car dealership, gas station, roofing business, and, most recently, the town post office and library. Both houses pictured on the left still stand.

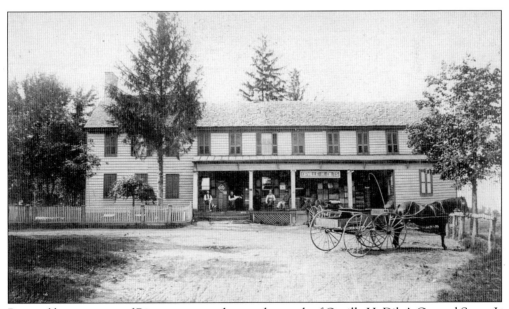

Pictured here, a group of Ringoes men gather on the porch of Orville H. Dilts's General Store. It was located between John Ringo Road and U.S. Route 179 but burned in 1895. The gentleman on the porch with long whiskers is Dr. Cornelius Larison.

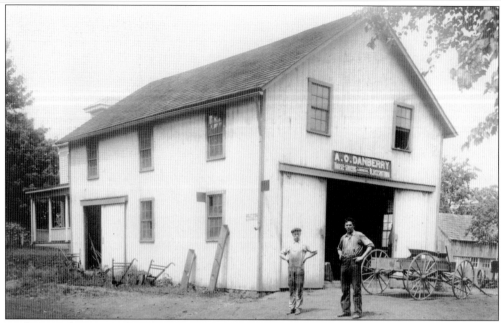

Arthur Danberry ran this blacksmith shop on John Ringo Road, where he did horseshoeing, blacksmithing, and general repairs. Later the building housed a Chevrolet dealership run by his son, Charles. It is still standing. (Courtesy of Charles E. Danberry.)

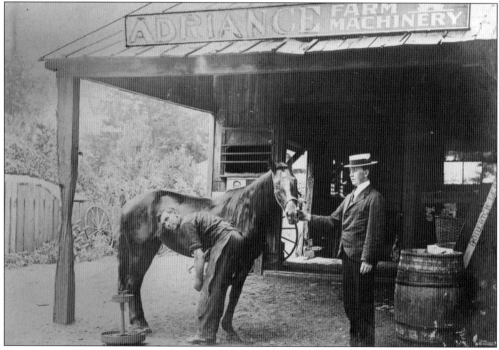

Joseph Croasdale bends to shoe a horse while Reverend Bresnaham of the Ringoes Baptist Church watches, around 1915. Croasdale's blacksmith shop was located in an alley just above Inslee's Tavern, between John Ringo Road and U.S. Route 179. The John L. Weber Brothers Carriage factory and wheelwright was next door.

William Case (on the bench, right) and others pose in front of William Case's Restaurant, built in the mid-1850s and located two buildings north of the Grange Hall in Ringoes. Later it became a Mutual Grocery Store and then an American Stores Company grocery store. In the 1960s, it was owned by Robert Titus and his wife and called the Village Grocery Store. (Courtesy of Paul Kurzenberger.)

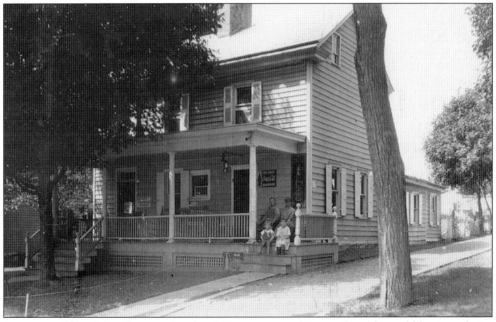

Artman and Bessie Lambert ran Lambert's Restaurant and Store where they sold homemade ice cream, newspapers, penny candy, and tobacco. Meals cost 75¢. They also supplied ice for iceboxes before electricity came to the village in 1927. In this 1921 photograph, they are seated on the porch with their children, Howard (also known as "Chief") and Catherine (Polhemus). (Courtesy of Teri Angelone.)

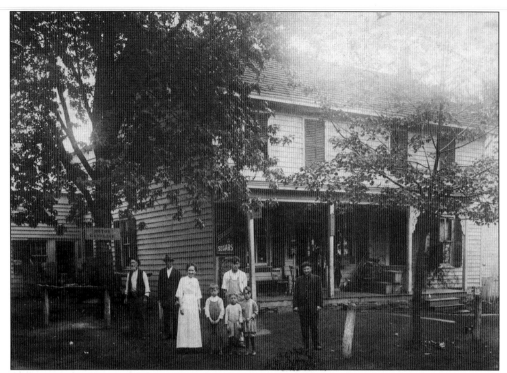

Above is a c. 1905 view of Elmer W. Holcombe's store, with the family gathered in front. Holcombe purchased the store from Edward Higgins and ran it until he died in 1956. Today it is the Carousel Deli. Although the hitching posts in front of the shop still got regular use, times were beginning to change. A sign advertising "motor gasoline" is tacked to the tree on the left. Below is a view of the same store after it was remodeled in the 1920s. Hitching posts are out, and gas pumps are in. Jessie and Elmer Holcombe still operated the store downstairs and lived upstairs; their son Kenneth Holcombe stands at the pump. The store was known as Chet's after Holcombe died. (Both courtesy of Betty Bollin.)

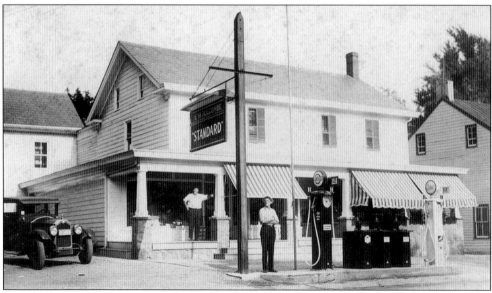

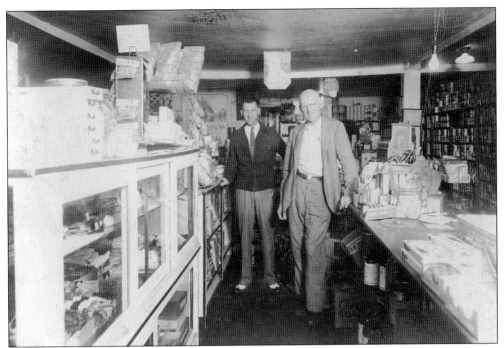

Howard Ruple (left) and Elmer Holcombe stand inside Holcombe's Ringoes store, around 1930. Embodying the ideal of a small-town general store, Holcombe appears to have a little bit of everything in inventory. (Courtesy of Betty Bollin.)

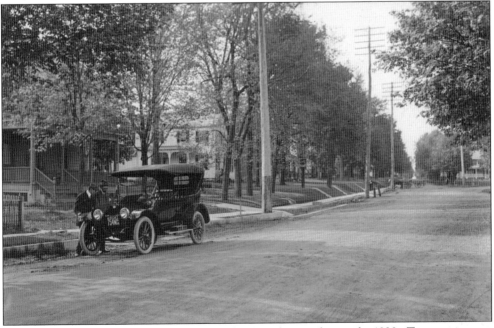

Not much has changed in Ringoes since this photograph was taken in the 1920s. Two men inspect a Model-T parked across from Holcombe's store; notice the horse and wagon farther north on John Ringo Road. All the houses pictured here still exist; Mom's Restaurant, now located in the grassy area on the right, is the only new building in this part of town.

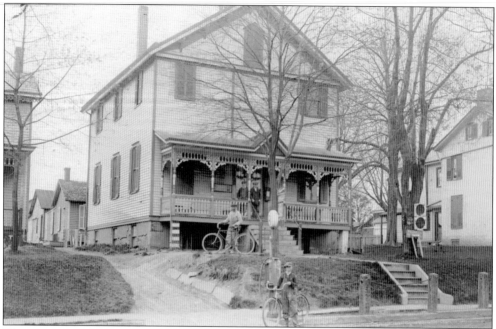

The International Order of Odd Fellows Lodge Hall was chartered in 1848 and met on the second floor of this building. The first floor housed Calvin Holcombe's general store, where customers could buy bolts of fabric or molasses tapped from a barrel. The Patriotic Order Sons of America, founded in 1847, also met here; Howard Parks is fourth from the left in the third row, below, at a meeting in the late 1890s. Charles Holcombe, the funeral director and Calvin's brother, used the rear barns as a mortuary and for hearse storage. Later local court met in these barns. Paul Cronce's barbershop was in the basement; the porch support on the left in the above 1915 photograph served as his barber's pole, painted in stripes. (Below photograph courtesy of Irvin Hockenbury.)

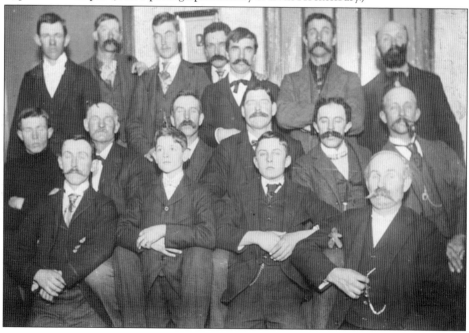

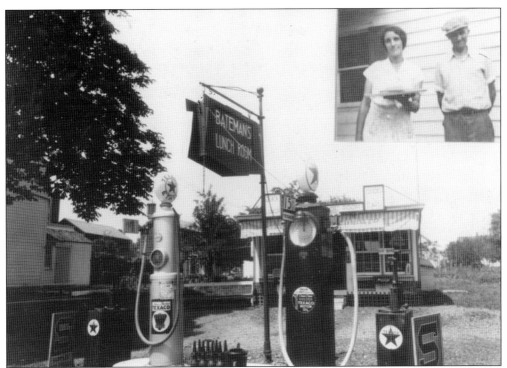

George and Harrietta Bateman, posing top right with one of Harrietta's famous pies, ran Bateman's Lunch Room and gas station on U.S. Route 179 three doors south of the Larison Lane intersection. Bateman's is shown here in 1929, when gas cost 15¢ a gallon. (Courtesy of Grace Cronce.)

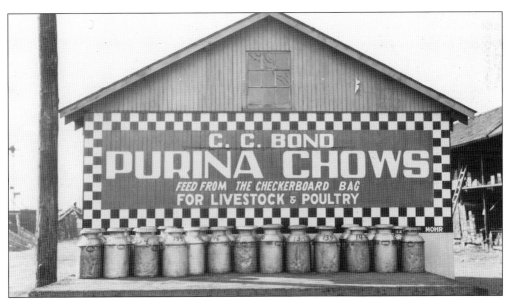

A Purina Chows advertisement decorates the side of Charles Bond's feed mill at the railroad station; the Ringoes Lumber Company is visible in the background on the right. One of the feed mill buildings was a collection point for the Harbison Dairy in Philadelphia. A milk train ran daily to Ringoes to pick up milk from the local farmers. (Courtesy of David Bond.)

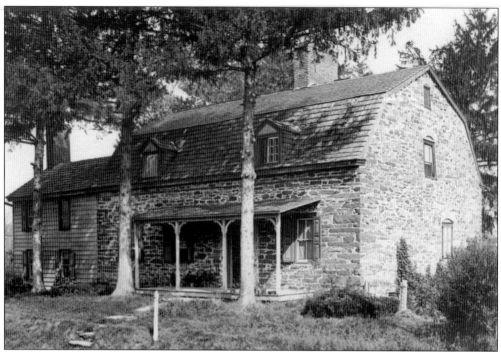

The Landis House is one of the oldest in Ringoes, built in 1750 by Henry Landis (or Heinrich Landes). During the Revolutionary War, the Marquis de Lafayette recovered from an illness here, under the treatment of Dr. Gershom Craven; the basement was used to imprison British soldiers. Landis was a well-known saddle maker. He had 24 children, and all the males entered his profession. Above is a view of Landis House sometime before 1920, when the clapboard addition on the left burned down. In *Within a Jersey Circle* (1910), George Quarrie laments that owner C. W. Johnson planned to remove the original dormers shown above, put on a modern roof, and enlarge the windows, as seen below. Pictured below, the house sports a neoclassical porch and three large dormers. Current residents Roger Paffitt and Lou Urciuoli won an East Amwell Historic Preservation Award in 2009 for their work restoring a more authentic 18th-century appearance. (Below photograph courtesy of Roger Paffitt and Lou Urciuoli.)

Ringoes has always had a lively social scene. Besides numerous fund-raisers, Ringoes had a social club in the late 19th and early 20th centuries. To the right is the cover of a dance card for its ice cream festival and ball held on June 13, 1899, at the Grange. Inside one could record partners for the quadrille, waltz, polka, and so forth. Pictured below, 1959 photographs show a more recent social hub: the Ringoes Tent Restaurant. It was attached to the rear of the old Amwell Academy Building, now the Harvest Moon Inn, and run by Jack Colligan of Colligan's Stockton Inn. Locals dined inside in the winter and under the tent in the summer. Unfortunately the tent restaurant closed after two successive hurricanes destroyed two very expensive tents. (Below photograph courtesy of William and Barbara Harrison.)

Strawberry

AND

Ice Cream Festival

AND

BALL

OF THE

RINGOES SOCIAL CLUB,

Ringoes, N. J.

Tuesday, June 13, 1899.

AFTERNOON & EVENING.

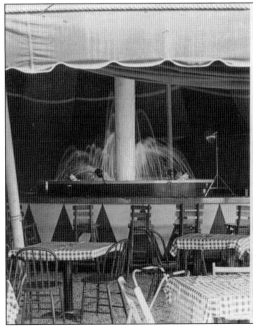
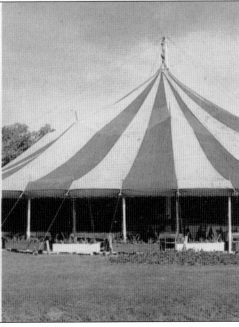

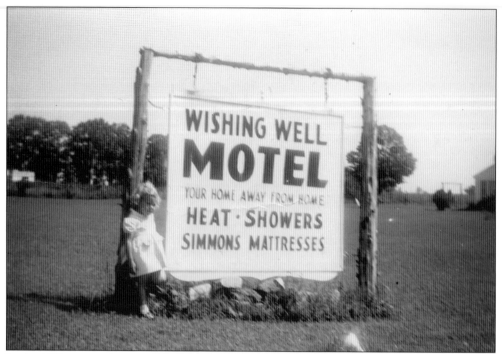

In the 1950s, a motel operated in Ringoes to the right of the present-day post office. The owners were Doug and Grace Cronce. In this 1952 photograph, their daughter Beverly poses by the sign for their "Wishing Well Motel." Today the building is their home. (Courtesy of Grace Cronce.)

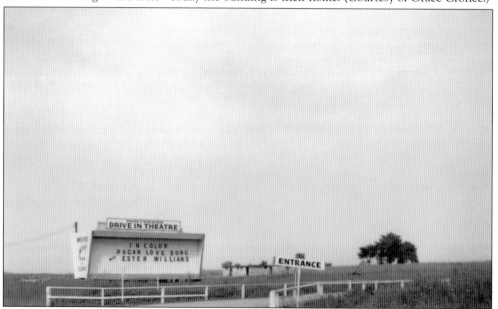

The Hunterdon Drive-In Theater, later the Ringoes Drive-In and Gem Drive-In, opened on October 24, 1950, where the 4H Fairgrounds is now. *Pagan Love Song*, advertised here, ran June 5–7, 1951; Allen's Esso Station in Lambertville offered the first 15 cars a free oil change. Gladys and Al Worthington were the original managers of this 400-car theater, which showed second-run and B movies. It closed in 1987. (Courtesy of James Walker.)

Three

HISTORIC HAMLETS

As the village of Ringoes took root, other settlements began dotting the fertile Amwell Valley. Around 1749, adverse winds blew a ship bound for New York off course to Philadelphia, where its stalwart German passengers, unfazed by their misfortune, decided to reach their original destination by traveling north along the Old York Road. They got as far as Pleasant Corner, just northeast of Ringoes, where they fell in love with the land. They built homes and a German Reformed Church. Later this area became known as Larison's Corner, after John W. Larison, keeper of one of the Old York Road's most popular taverns, which featured ballroom dancing downstairs and a gambling den upstairs where professional card players fleeced farmers of their hard-earned cash.

South of Larison's Corner, the prosperous settlement of Old Amwell flourished around William Dawlis's mill. Built around 1730, the mill harnessed the power of a small brook flowing from a spring in the Sourland Range to grind cornmeal for hoecakes. Farther south, a tannery and mill became the focal point of New Market or Linvale. By 1834, this hamlet had grown to include a half-dozen homes, a tavern, and a general store. Wertsville, east of Ringoes, is named for the Werts family and included a school, post office, store, blacksmith, and shoemaker's shop.

Along the Old York Road, where the stagecoach ran regularly, the hamlets of Reaville and Clover Hill prospered. Reaville (originally Manner's Tavern, then Greenville) was renamed in the 19th century for Runkle Rea, a prominent resident and its first postmaster. This hamlet straddles the East Amwell and Raritan Township borders and flourished as a stagecoach stop until the railroad chugged into Flemington. Clover Hill, which stretches into Hillsborough Township, grew to include a hotel, church, blacksmith shop, post office, cider mill, and 15 houses by 1880. Other hamlets or settlements in East Amwell include Unionville, Van Lieus Corner, and Buttonwood Corners.

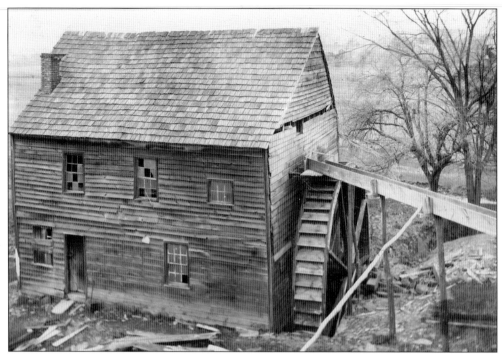

Construction of Dawlis Mills began in 1732 on a 265-acre parcel of land a half mile south of Ringoes. This photograph details the wooden trough (right), which deposited water from a nearby millpond to the top of the wheel, providing the waterpower that operated the mill. Area farmers depended on these mills to grind quality flour for breads and cakes.

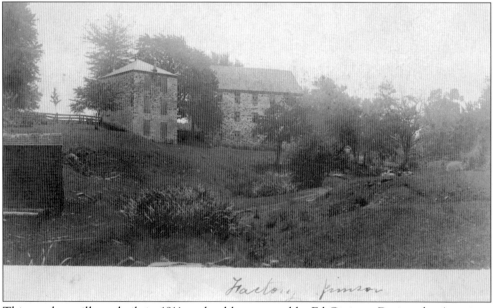

This woolen mill was built in 1811 on land later owned by Ed Ginison. During the American Revolution, mill owner Jacob Race helped the cause for independence by supplying flour to the Continental troops. Seven mills operated on the Dawlis tract at its peak. The mills prospered until the mid-1800s.

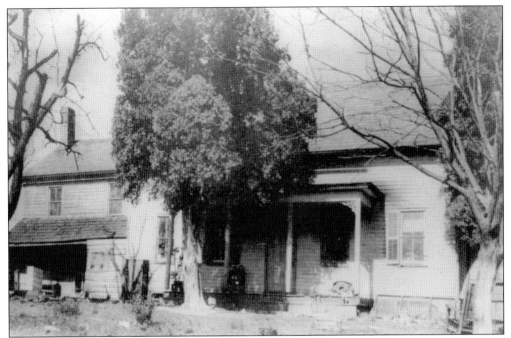

Peter Fisher and his wife came to the Amwell Valley from Germany in 1729. They built this home about a half mile south of the Old York Road west of Rocktown. The couple raised six sons and two daughters here, several of whom became prominent citizens of the area. Peter is buried in the cemetery off Old York Road in Larison's Corner. (Courtesy of Irvin Hockenbury.)

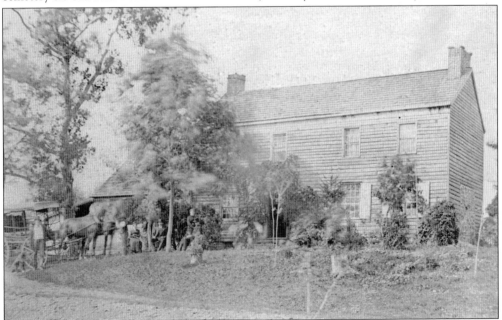

Words scribbled on the flipside of this photograph indicate Brig. Gen. Nathan Price may have owned this home. Price served in the American Revolution, operated a tavern in town, and was an active member of the United Presbyterian Church. Price built his home east of present-day U.S. Route 31 and raised a large family there.

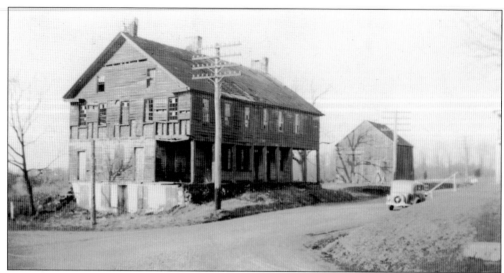

John Larison's Corner Tavern at Old York Road and Dutch Lane was abandoned when this photograph was taken around 1930. During the mid-1800s, stagecoach passengers and farmers frequented the tavern to dance, drink, and gamble. One popular tale from tavern days involved Prime Hoagland, who would break a wheel of cheese with his head for drinks. One day, practical jokers wrapped a millstone in cheesecloth. Hoagland's fate is uncertain.

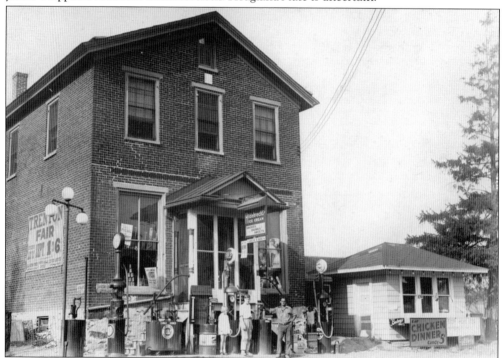

British troops may have plundered the Linvale General Store on present-day U.S. Route 31 while investigating whether it contained silk fabrics or weapons. Later the British demanded residents report to the store to sign loyalty oaths. This building has two cornerstones: one dating from 1770, the other from 1776. Currently occupied by Reid Plumbing Products, the building functioned as a store for over 200 years. This photograph was taken in 1929.

The farm presently owned by the Unionville Vineyards on Rocktown Road originally was part of the largest peach orchard in the United States. A "rust" blight wiped out the peaches after the Civil War, forcing farmers to convert the land to an apple orchard. In 1900, it became a dairy farm, and later grain was harvested. Unionville planted its first vines in 1982. (Courtesy of Louise Kenney.)

Abram Quick Van Lieu (standing, left) ran this general store on Wertsville Road near Rileyville Road. The Van Lieu family also owned several houses in the area and ran a hotel and tavern across the street from the store. Pictured with Abram Quick Van Lieu are Rachel Caroline Van Lieu (center) and Catherine Herron Van Lieu (Abram's wife, right). The boy sitting on the porch is unidentified.

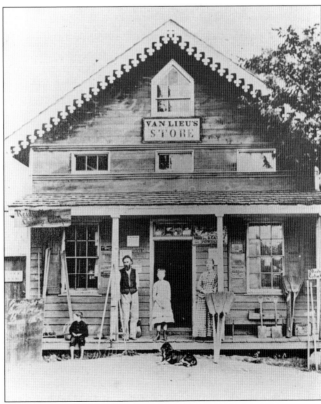

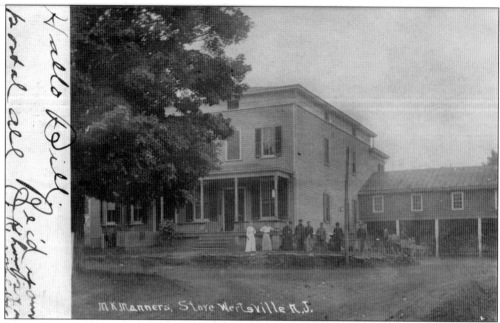

Long before present-day Lindbergh and Wertsville Roads were paved, this building served as a general store. Peter Van Dyke Manners built this store in 1883, and his family lived upstairs. The sheds near the building housed horse-drawn school buses. Today it is known as Peacock's General Store, and the sheds are now apartments. (Courtesy of Paul Kurzenberger.)

Yourself and Lady are cordially invited to attend a

⇥✳SOCIAL BALL,✳⇤
—AT THE—
NEW ✣ STORE ✣ OF ✣ PETER ✣ V. ✣ D. ✣ MANNERS,
At Wertsville,

On Wednesday, May 30th, 1883

Grand March at 6.30 P. M., sharp. Music will be furnished by the Lambertville String Band.
Refreshments furnished by J. H. Gray, of Flemington.

———o———
Managers—A. YOUNG, H. LANE, W. E. STOUT, J. H. MANNERS.

Besides selling goods to area farmers, the Manners store served as a social gathering place for the hardworking residents of the Amwell Valley. Here is an invitation to a ball featuring food, dancing, and music by the Lambertville String Band. (Courtesy of Deborah Lentine.)

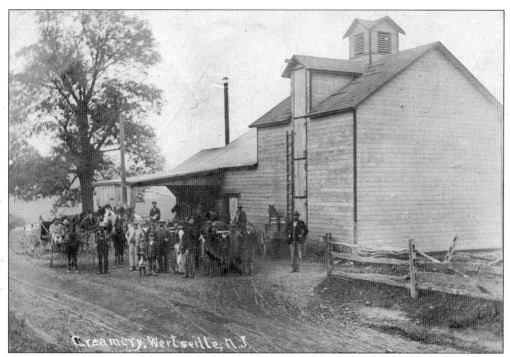

Creamery, Wertsville, N.J.

The Wertsville Creamery was a one-story frame building owned by Hernig and Northrup during the early 1900s. Over a half-dozen dairies and creameries operated in East Amwell until the 1920s. The Wertsville Creamery ran afoul of state health inspectors in 1907. They demanded the owners replace a leaky wooden floor with a concrete one and complained that the building was infested with flies.

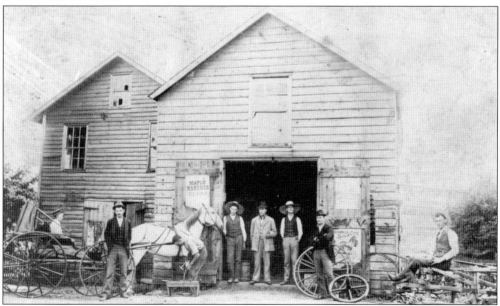

Blacksmith shops in the area ran a brisk business thanks to the bustling stagecoach line and busy farmers. This blacksmith shop in the hamlet of Wertsville operated in the late 1800s. Pictured on the far right is Howard K. Stryker.

This building went from forging young minds to forging steel. One section of this structure served as a school in Ringoes in 1854. The building was moved to Wertsville Road, and George Strimple Sr. ran his blacksmith shop from it. Later Charles Wilson expanded it for his carpentry business.

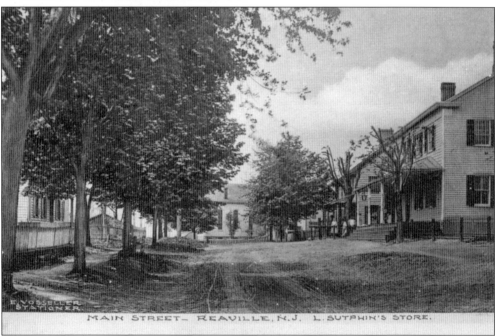

MAIN STREET— REAVILLE, N.J. L. SUTPHIN'S STORE.

Looking down Amwell Road in the hamlet of Reaville, one can see L. Sutphin's store on the right and the Amwell First Presbyterian Church in the background. Reaville, at this time, was considered a "new and flourishing village" with a school, hotel, store, and several mechanics shops. Originally called Greenville, the hamlet's name was changed to honor a prominent citizen and its first postmaster Runkle Rea. (Courtesy of Paul Kurzenberger.)

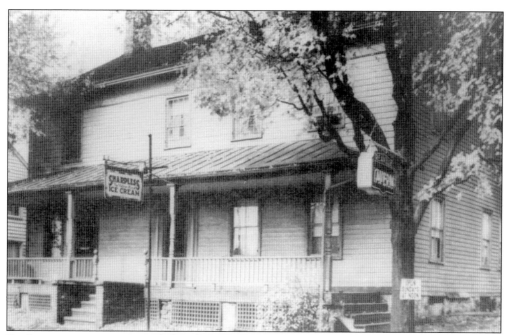

By the time someone snapped this photograph around 1930, the Reaville Tavern had served as a popular gathering spot for locals and travelers for 150 years. The first mention of a tavern in the hamlet is in a petition for a license in 1779 by Joseph Layboyteaux. In 1790, John Manners purchased the tavern and ran it for many years. (Courtesy of Irvin Hockenbury.)

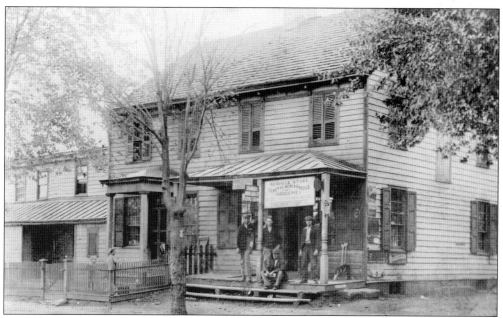

Reaville residents frequented this general store, which sold everything from cigarettes to candy for many years. During the 1930s, William and Edith Scott owned the store and lived in the portion of the building with the fenced-in yard. The store also served as a post office, and the front porch was a school bus stop. (Courtesy of Doris Snyder.)

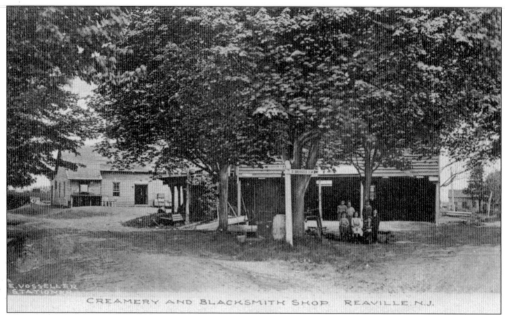

Several children posed in front of a blacksmith shop in Reaville located at the fork of Old York and Amwell Roads. Notice the signpost pointing out the distances to Three Bridges and Flemington. The building to the left is the Reaville creamery. Canadian native W. W. Grant served as superintendent of the creamery and helped supervise construction of a new facility around 1900. (Courtesy of Paul Kurzenberger.)

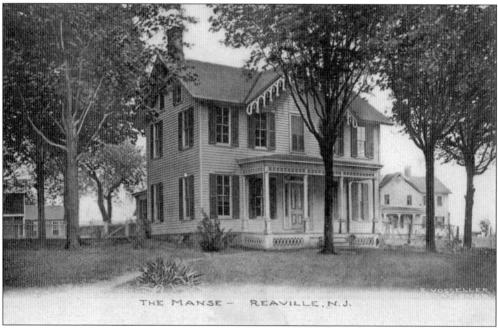

Now a private residence, this home served as the manse for the Amwell First Presbyterian Church in Reaville for many years. The manse was built in 1865 on land purchased from Robert R. Smith at a cost of $5,000. Several pastors, such as the Rev. John Kugler and the Rev. John Beekman, enjoyed many a summer's day on the front lawn of this home. (Courtesy of Paul Kurzenberger.)

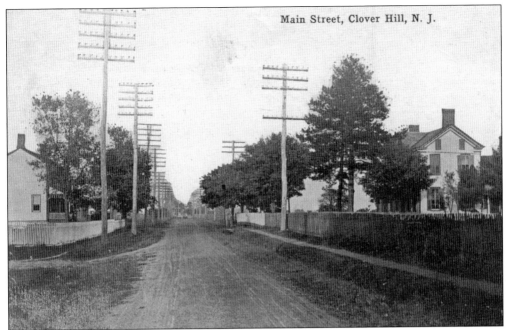

This photograph looks down the Main Street of Clover Hill in the early 1900s. This hamlet was known by several different names—including Coughstown and Cux Town—before garnering the familiar name of Clover Hill in 1848. The hamlet quickly grew to include a hotel, store, blacksmith shop, and post office. (Courtesy of Paul Kurzenberger.)

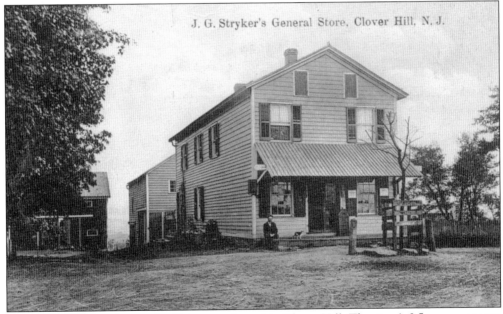

J. G. Stryker sits on the porch of his general store in Clover Hill. The store's 3.5–acre property, which previously had been owned by J. B. Bartow, included a barn, a stable, and a wagon house. (Courtesy of Paul Kurzenberger.)

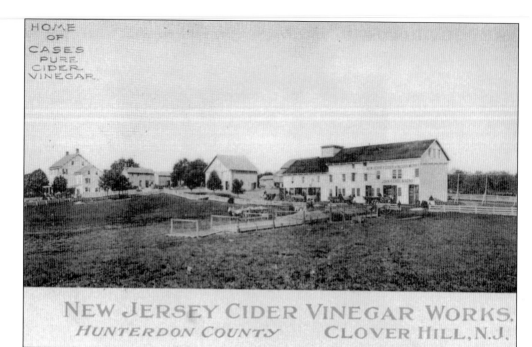

NEW JERSEY CIDER VINEGAR WORKS.
HUNTERDON COUNTY CLOVER HILL, N.J.

Zebulon Stout started the New Jersey Cider Vinegar Works on his farm between Voorhees Corner and Reaville before partnering with John Case in the mid-1870s. The works were relocated to Case's farm in Clover Hill where this photograph shows a flourishing business. Case sold his business to E. P. VanAtta in 1906 who eventually built a new cider plant in Flemington. The buildings burned down in 1957. (Courtesy of Sue Posselt.)

ESTABLISHED BY STOUT & CASE, A. D. 1869.

GENUINE
CIDER VINEGAR,
STRICTLY PURE.

WHITE
WINE VINEGAR.

SWEET
APPLE JUICE,
DURING
FALL & WINTER MONTHS.

All guaranteed equal to, or better than any on the market.

◁ **JOHN P. CASE,** ▷

MAKER OF CIDER AND VINEGAR,

P. O. ADDRESS, CLOVER HILL, HUNTERDON COUNTY, N. J.

John Case's mill was the largest manufacturer of cider in the area. This advertisement promoted the white wine vinegar and apple juice that Case shipped throughout the region from the late 1870s to early 1900s. The farm produced and sold between 2,500 and 5,000 barrels of apple cider vinegar annually. (Courtesy of Hermione Van Doren.)

Four

CORNERSTONES OF THE COMMUNITY

East Amwell's diverse residents have always been united by a strong sense of community and camaraderie. Nothing exemplifies this spirit better than the organizations and social events that regularly brought residents together in a spirit of civic responsibility or festivity. The cornerstones of this community were groups such as the Grange, service clubs, and community theater. The spirit of service also motivated residents to offer active support for American war efforts during World War I and II.

Originally formed in 1873 as an advocacy group for farmers, the Ringoes Grange embodies local values and a commitment to community. The Grange Meeting Hall was purchased in 1909 as a formal meeting place for its predominantly agrarian members. Although the mission of the Grange has evolved away from a strictly agricultural focus over the years, it remains committed to public service. Today the Grange conducts fund-raisers to support local schools, sponsors a Little League team, and organizes events that celebrate the community such as the annual Pumpkin Festival.

The Ringoes Firehouse was built in 1927 to support the volunteer firefighters of the Amwell Valley Fire Company. To this day, the fire company conducts annual fund-raisers, as it relies on the generosity of the residents who depend on its fire protection services. The Amwell Valley-Ringoes Rescue Squad is another nonprofit service organization, formed in 1957 and dedicated to helping the sick and injured in the Amwell Valley. Its members maintain one of the fastest response times for all-volunteer rescue squads in New Jersey.

Community theater was popular in East Amwell in the early 20th century, including the performance of minstrel shows where white actors in blackface makeup would perform musical numbers. The stock characters of the minstrel show perpetuated often-negative African American stereotypes, and the civil rights movement put an end to these performances. Parades, fairs, and other festivities continue to offer residents an opportunity to bond and celebrate the local community. Since 2004, East Amwell has also hosted countywide events at the new Hunterdon County Fairgrounds in Ringoes, particularly the Hunterdon County 4H and Agricultural Fair, an annual event including exhibitions and shows celebrating Hunterdon's rich agricultural heritage.

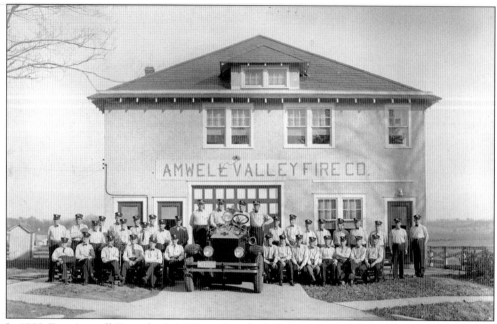

In 1923, East Amwell Township's 1,100 residents had no fire protection services. On November 27, 1923, citizens met at Kirkpatrick Memorial Church to discuss forming a volunteer fire company. By December, they had already raised $1,400. On January 21, 1924, the Amwell Valley Fire Company was incorporated. The volunteer firefighters donned their new uniforms and posed in front of their new firehouse for this photograph, taken November 29, 1930.

Edward Quick is shown here in 1983, after 50 years of active service in the Amwell Valley Fire Company. He served as chief from 1952 to 1957 and was still active at the time of his death in 1989. Quick served on many township and county committees and was an avid collector of materials related to East Amwell history. East Amwell Township now owns his extensive local history collection.

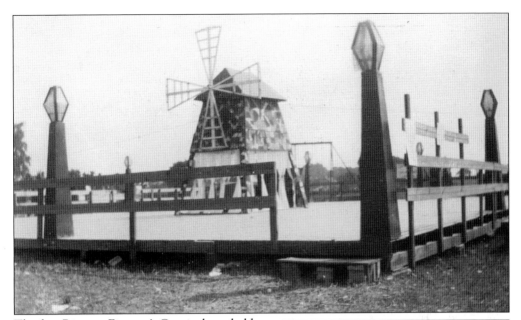

The first Ringoes Firemen's Carnival was held in 1924 to raise funds to build a firehouse. By 1928, the carnival had grown so popular it needed more space and was relocated to a lot behind the current firehouse. The first three years featured a Dutch Carnival theme, with a huge Dutch windmill with four blades illuminated by electric lights located at the center of the dance floor, pictured above. The orchestra sat beneath the windmill; the dance floor was one of the largest open-air dance floors in the state. In 1930, the theme was changed to an Oriental Carnival. The entrance mimicked a Japanese pagoda and a large statue of Buddha reigned over the dance floor. The last carnival was held in 1934. (Above photograph courtesy of Margaret Gritzmacher; right photograph courtesy of Harriet Barrick.)

ORIENTAL CARNIVAL
Ringoes, N. J.
July 30th to August 6th, Inc.

U N I Q U E U N U S U A L

Here you will find a bit of the Far East faithfully reproduced. Designs by John R. Browne, of Ringoes.

Dance Floor Larger and Better

The dance floor will be of larger area and in a setting which represents a Buddhist temple with a large statue of Buddha as the dominating feature.

Good Music

Many Unique Decorative Effects

A great deal of effort has been expended in making this the most unusual, unique and attractive carnival in the State. In addition to the features mentioned above, the Ladies Auxiliary will serve wonderful things to eat in a Japanese Park at the entrance to the grounds.

The Bingo Stand will be in the form of a Japanese Pagoda and the other stands will represent small Japanese temples. All attendants will be in oriental costumes.

$25 Merchandise Certificate Given Away Each Night.

Spaces for Rent to Exhibitors
Free Parking Space on Carnival Grounds
AMWELL VALLEY FIRE COMPANY

Moreau & Moreau, Printers, Flemington, N. J.

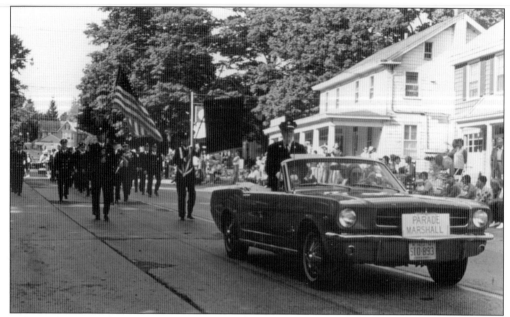

On September 8, 1973, the Amwell Valley Fire Company held its 50th anniversary parade, with former Chief Quick as the parade marshal. In this photograph, Quick perches in the back of a Mustang driven by Sandy Martin. This milestone in the history of the fire company was a great event in Ringoes; the company distributed its first comprehensive history of the unit at the parade.

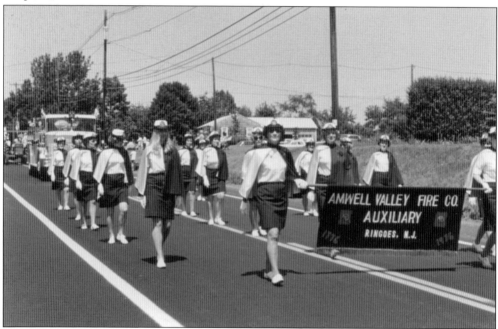

The Ringoes Ladies' Auxiliary was organized in March 1928 and had 19 members. When firemen are called to a fire, the ladies supply them with beverages, sandwiches, and soup. The auxiliary raises money for the company by catering weddings, parties, and banquets at the firehouse. Pictured here, the auxiliary is shown marching in the Ringoes bicentennial parade in 1976.

Local fire companies frequently cooperated to fight large blazes. In 1930, Charles and Anne Lindbergh purchased their 425-acre estate, Highfields, which straddled the Hopewell-East Amwell border in the Sourlands. When a devastating fire disrupted construction on their new house, several local companies responded. Pictured here, an unidentified and seemingly exhausted fireman from the Hopewell Fire Company takes a rest. (Courtesy of the New Jersey State Police Museum.)

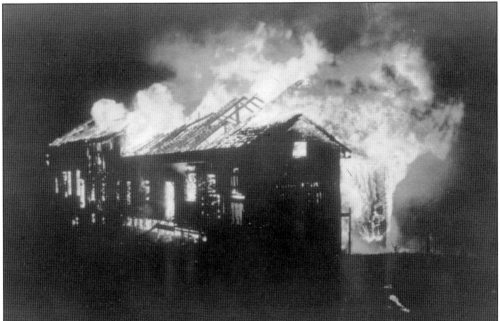

This photograph was taken on the night of July 13, 1957, after lightning struck the building that formerly housed Case's Cider and Vinegar Works, on the corner of Cider Mill Road and Amwell Road. Despite heroic efforts by the Amwell Valley Fire Company and neighboring fire companies, the resulting blaze could not be contained, and the structure burned to the ground. (Courtesy of Hermione Van Doren.)

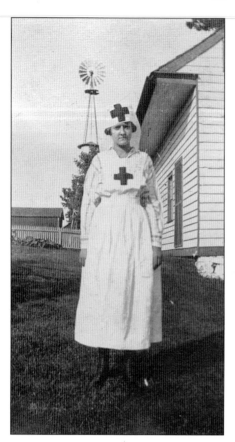

When World War I broke out, the East Amwell community mobilized to help with the war effort. During the war, the 1918 Influenza Pandemic swept America as well. Kathryn Sutphin became a Red Cross nurse to do her part. She is shown here in uniform on her family's farm on Dutch Lane, around 1917–1918, when she was about 16 years old. (Courtesy of David Bond.)

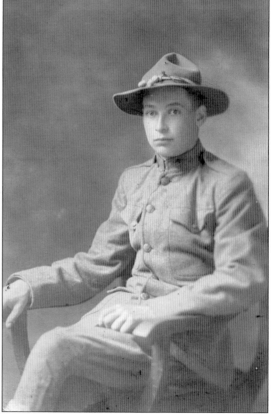

Frank Ashton, shown here in his uniform, was born near Buttonwood Corners in the Sourlands, where his father was a peach farmer. At age 18, he enlisted to fight in World War I and went to Georgia for training. He served overseas and came home unscathed, moving to Hillsborough where he became a conductor on the railroad. (Courtesy of Alberta Flagg.)

Many East Amwell boys served in World
War II. To the right is Stanley Wielenta,
son of Justyn and Susan, photographed
upon his discharge from the U.S. Army
in 1945. East Amwell residents also
supported the war effort by participating
in scrap drives, using war coupon books,
and saving milk weed silk to fill soldiers'
life preservers and peach pits for gas mask
filters. There were three Observation
Towers in East Amwell: one near the
railroad station, one on the outskirts
of Ringoes, and one near Wertsville.
Local men and women operated the
watchtowers 24 hours a day, pairing up
for two-hour shifts. Using charts on the
wall showing airplane silhouettes, they
phoned the civil defense headquarters
to identify passing planes and their
direction of travel. Pictured below,
Beatrice Quick stands on the Wertsville
platform in May 1942. (Right photograph
courtesy of Ronald Wielenta.)

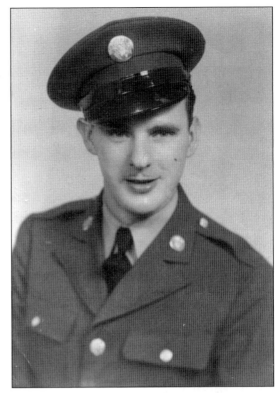

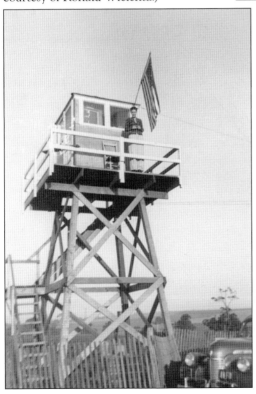

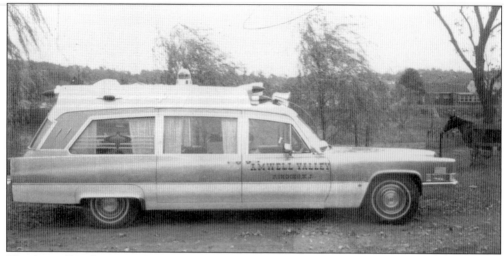

The Amwell Valley Ambulance Squad (now the Amwell Valley-Ringoes Rescue Squad) began their volunteer service in 1957 with the purchase of a secondhand 1936 Packard Ambulance, which was housed in a bay at the firehouse in Ringoes. However, as the ambulance squad expanded its services, they updated their equipment and purchased the new 1969 Cadillac ambulance pictured here. (Courtesy of the Amwell Valley-Ringoes Rescue Squad.)

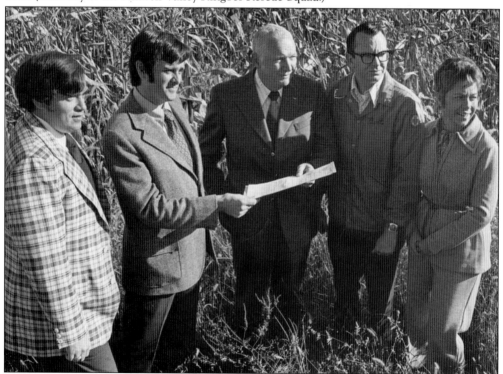

In 1975, Round Valley Realty, a major Hunterdon County landowner, donated a 2-acre site in Ringoes for the construction of a permanent rescue building. Pictured here from left to right are Philip Faherty, counsel to the Amwell Valley Ambulance Corps (AVAC); Joseph Therrien of Round Valley; A. T. Humbles, AVAC president; Bert Godown, AVAC vice president; and Ginger Nicoletti, chairman of the squad's building fund. (Courtesy of the Amwell Valley-Ringoes Rescue Squad.)

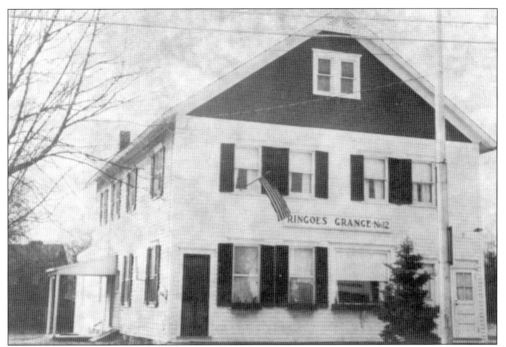

In 1873, Amwell Valley residents formed a farmers' group known as the Ringoes Grange No. 12, Patrons of Husbandry. This was the first Grange in Hunterdon County. Initially they met at the Washington Hotel and later the Kirkpatrick Memorial Church, Odd Fellows Hall, and Lande's Hall across from the railroad station (now destroyed). In 1909, the group purchased Bond Hall, shown here, the building they still use. (Courtesy of Harriet Barrick.)

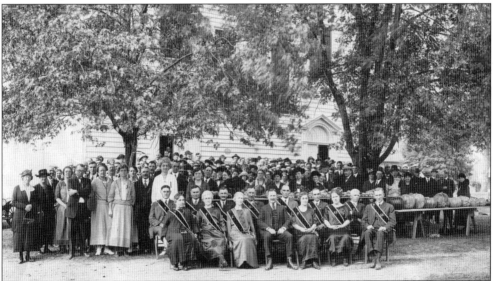

The Grange Movement grew rapidly. One of its first activities was cooperative purchasing. An appointed Grange Purchasing Agent ordered various items and seeds for members from the Grange Supply House in Philadelphia. Shown here is a Grange meeting at Larison's Corner Church, around 1920. The sashes represent different officers in the Grange, such as master overseer, steward, gatekeeper, the three lady graces, and so forth. (Courtesy of Ellen Ramberg.)

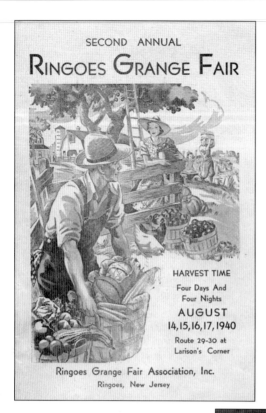

SECOND ANNUAL

RINGOES GRANGE FAIR

HARVEST TIME

Four Days And
Four Nights

AUGUST
14, 15, 16, 17, 1940

Route 29-30 at
Larison's Corner

Ringoes Grange Fair Association, Inc.

Ringoes, New Jersey

Annual Ringoes Grange Fairs began in 1939. According to this 1940 program, the fair was intended "to serve an agricultural need and advance the fraternal, social, educational and moral purposes of the Grange." Held at Larison's Corner, this fair was more youth-oriented than the Hunterdon County Agricultural Fair in Flemington, forbidding games of chance and alcohol. Activities included milking cows, chicken-catching contests, bingo, and music. (Courtesy of Harriet Barrick.)

The Grange was the social hub of East Amwell. From at least 1930, the Grange members produced plays, first at the firehouse and later at East Amwell School. Some of the early plays included *Three Little Ghosts* (1930), *Adam and Eva* (1932), *The Blue Bay* (1933), and *Just Too Bad* (1937). Here are Charles Rauschert and Elizabeth Philhower (Rauschert) in *Adam and Eva*. (Courtesy of Harriet Barrick.)

Program

ACT ONE

1. "The Ringoes Jamboree"CHORUS
2. "No Visitors Allowed"
 INEZ Betty Jane Brelsford MARGE Judy Rauschert
 NURSE Clara Barrick
3. SpecialtyBuddy Adler
4. "Dance Me Loose"Jeanette Omdal
 Assisted by Mary Kay VanOpynen
5. "Serenade To An Old-Fashioned Girl"CHORUS
6. SpecialtyMartha Cromwell
7. "The Syncopated Clock"Barbara and Beverly Burenga
8. "I Want What I Want When I Want It"Louis Simonye
9. "Some Like Them Thin"
 PEGGY Jeanette Ash HAROLD Artie Polenz
10. "Is It All A Dream?"Mimi Connell
11. "Tomorrow"Lola Roe
12. "Get Away For A Day In The Country"CHORUS
13. "Star Dust"
 Lee Buchanan, Burdette Polhemus, Stanley Lederman
14. "Blackmail"
 JOHN MARSHALTON .. Richard Gulick BOB .. Norman Fulper, Jr.
 BETTY MARSHALTON .. Harriet Rauschert
15. "Bad Timing"Dolly Arch
16. "Jealous"Peggy Hunt
17. "Tulips and Heather"
 Claire Wright, Bob Fulper, Gladys Polenz
18. "At The Movies"
 FATHER Ellsworth Higgins MOTHER Elizabeth Rauschert
 WILLIE Kenny Cromwell
19. "With A Song In My Heart"Basil Negoescu
20. "This Is My Country"CHORUS

ACT TWO

1. "April Showers"Dorothy Hellyer and CHORUS
2. "A Near Tragedy"
 GEORGE Dorman Barrick JOHN James Fisher
 LOIS Betty Fisher
3. "Be My Life's Companion"Gladys Polenz, Bob Fulper
4. "Rosie O'Grady"Karen Connell
5. SpecialtyTed Brelsford
6. "Down Yonder"CHORUS
7. "Because of You"
 Lee Buchanan, Burdette Polhemus, Stanley Lederman
8. "Choon Gum"Bonnie Hunt
9. "Stormy Weather"Georgianna Pavlica and CHORUS
10. SpecialtyElizabeth Wilson
11. "Let Yourself Go"Dolly Arch
12. "Aren't We All?"Basil Negoescu
13. "The Same Old Thing"
 WAITER Michael Dorio CUSTOMER Ted Brelsford
14. SpecialtyHugh Van Gorder
15. "Let's Take An Old-Fashioned Walk"CHORUS
16. "Zigeuner"
 Shirley Hildebrant, George Hildebrant, Mimi Connell
17. "Serenade"Louis Simonye
18. "Just Another One"
 PETER Lee Buchanan DAISY Martha Cromwell
19. "Please Don't Talk About Me"Lola Roe
20. "We'll See You In Our Dreams"Everyone

CHORUS

Dorothy Hellyer, Georgianna Pavlica, Gladys Polenz, Claire Wright, Florence Burenga, Jane Dilts, Sara Lambert, Harriet Rauschert, Augusta Wachsmuth, Betty Fisher, Jeanette Omdal, Betty Sutphin, Gloria Drake, Stella Mannino, Mildred Larason, Eleanor Van Lieu, Sara Hunt, Mary Kay VanOpynen, Lola Roe, Betty Jane Brelsford, Judy Rauschert, Sara Higgins, Bob Fulper, Basil Negoescu, Kenny Cromwell, William Wachsmuth, Art Stillwell, Louis Simonye, Michael Dorio, Dick Smith, Harry Kendig, Dick Gulick, Lee Buchanan, Ellsworth Higgins.

INMATES

Charlotte Buck, Fred Ash, Tom Burenga, Cary Holcombe, Sara Higgins, Beulah Van Lieu, Louanna Burenga, Emil Pavlica, Alex Belonsoff, James Fisher.

Pianist: ROBERT BARLOW Drummer: DICK YARD

PRODUCTION STAFF

Gladys Polenz, Elizabeth Rauschert, Robert Barlow, Artie Polenz, Sara Higgins, Eleanor Connell, Claire Wright, Jack Spahn, Milton Hockenbury, Marie Pavlica, Jack Connell, Rosamond Affleck, Mary Hamp, Doris Bey, Mildred Larason, William Wachsmuth.

The Grange produced the Jamboree, a musical talent and variety show, from 1950 to 1958. The program opened and closed with a full chorus number. The rest of the show consisted of children performing, dance and musical numbers, comedy skits, and a minstrel section usually performed in blackface makeup. Above is the program from the 1952 Jamboree. It featured stock minstrel characters known as the "End Men," including the Preacher, Five Foot Two, Ragg Mopp, Gold Dust, Po'K Chop, Sambo, and Doc. They sang and cracked jokes about locals in the audience. Pictured below, from the 1952 Jamboree are, from left to right, Art Stillwell, Bob Fulper, Joe Adda, Lou Simonye (at the microphone), Tom Burenga, Dick Gulick, and Artie Polenz. (Both courtesy of Harriet Barrick.)

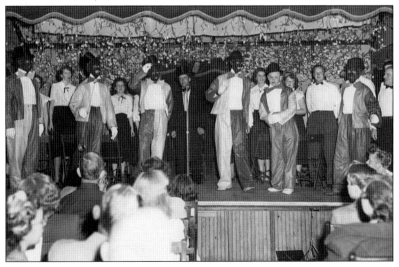

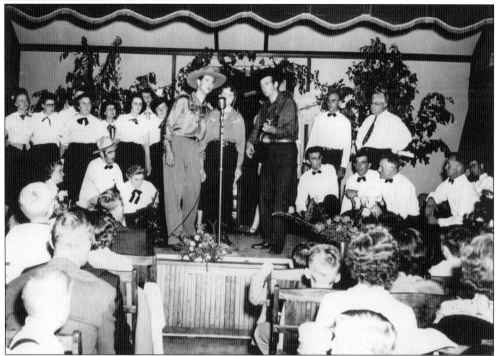

Pictured above, from the 1956 Grange Jamboree are, from left to right, (kneeling, first row) Elizabeth Rauschert, Ted Brelsford, Betty Jane Brelsford, Ken Stilwell, Mike Dorio, Bill Wachsmuth, Artie Polenz, and Fred Ash; (standing, second row) Florence Burenga, Mildred Larason, Augusta Wachsmuth, Sara Hunt, Jeanette Ash, Dot Hellyer, Bob Fulper, Gladys Polenz, Joe Adda, Alan Sutphin, and Walter Hunt. Many of the musical numbers in the Grange Jamboree involved children singing duets, performing tap dances, and delivering comedy routines. Pictured below, from the 1956 Jamboree, are Kenny and Bobby Hunt performing "Teen-Age Prayer." (Both courtesy of Betty Jane Biache.)

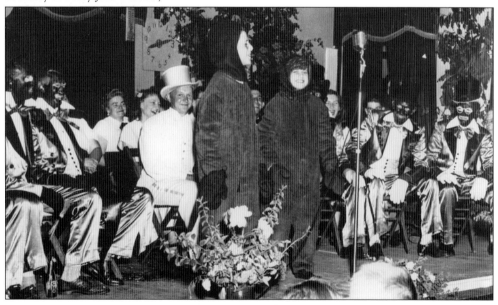

Five

ENRICHING MIND AND SPIRIT

Religion and education have been important influences on the lives of East Amwell residents since the 18th century. Places of worship and schools were established throughout the community, providing citizens with formal settings to develop spiritual and intellectual character.

In the 18th century, various Christian denominations founded churches in East Amwell. Some, like the German Presbyterian congregation at Larison's Corner, expanded over time; the Presbyterian church at Larison's Corner and Kirkpatrick Memorial Church in Ringoes both grew from this 18th-century seed. The Reaville Presbyterian Church and the Linvale Methodist Church continue to offer services for residents. Others, like the 18th-century Episcopal Church of St. Andrews and the Baptist church in Ringoes, closed their doors as congregations dwindled; both buildings have disappeared. Two stone churches, the Quaker meetinghouse and the Baptist church in Wertsville, have been converted into private residences. In addition to conducting baptisms, marriages, and funerals, East Amwell pastors often gave sermons at multiple local churches.

East Amwell also fostered intellectual pursuits. Ringoes was home to respected private academies like the Amwell Academy and Larison's Seminary and Academy of Science and Art. Early schools for local children were often simple, one-room structures, built from logs or stone (later sawn lumber) and lit by kerosene lamps. Students would walk to school for up to several miles, and their attendance was often irregular, dependent on the weather and responsibilities at home such as planting and harvesting. A single teacher taught the pupils in a multiage environment; classes might include students ranging from primary through secondary grade levels. Although the schoolhouse in Unionville is no longer standing and others have been converted into residential and commercial buildings, local students now receive a strong educational foundation at East Amwell Consolidated School, built in 1938.

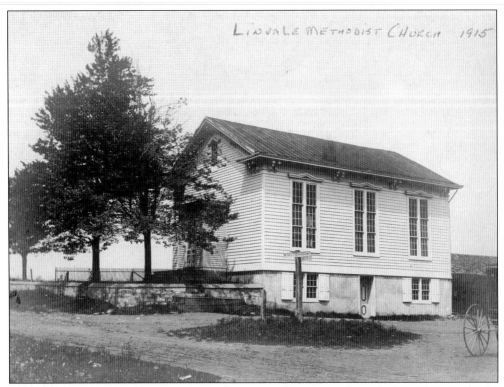

The Linvale Methodist Church was founded in 1844 by a group that split from the Woodsville Church; the current church was built in 1858. The photograph above shows the church in 1915, including the horse sheds in the rear. In addition to housing buggies like the one on the right, the sheds were sometimes used as shelter by groups of gypsies moving through the area. The road in front of the church, now U.S. Route 31, was still a narrow dirt lane. The photograph below shows the interior of the church, which looks very much the same today. (Courtesy of Linvale Methodist Church.)

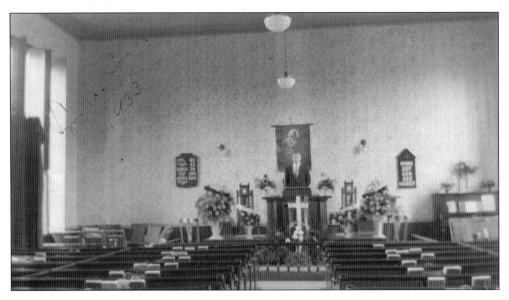

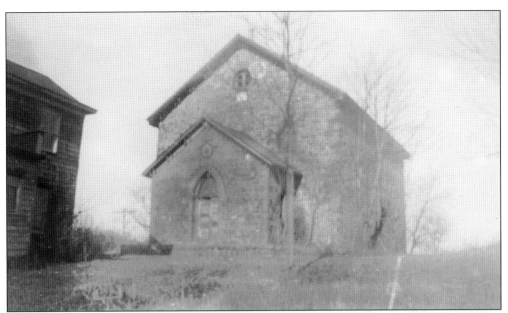

In March 1834, eight members broke from the Flemington Baptist congregation and founded the Wertsville Baptist Church, including N. O. and Mary Durham, Malon and Ann Higgins, Abraham S. Van Doren, Abraham Larison, Mary Carr, and Elizabeth Young. The stone church was built by 1836 on land donated by James Servis and Betsey Hoagland. Although it was the center of the Wertsville community for a time, membership dwindled in the 20th century, and it closed in 1908. The building fell into disrepair and was used as a machine shop, chicken house, and even a garage before John and Judy LePree purchased it in the 1990s and restored it as a residence and antiques shop. Miraculously the altar shown to the right was never torn out and remains in the building. (Right photograph courtesy of Carol LePree.)

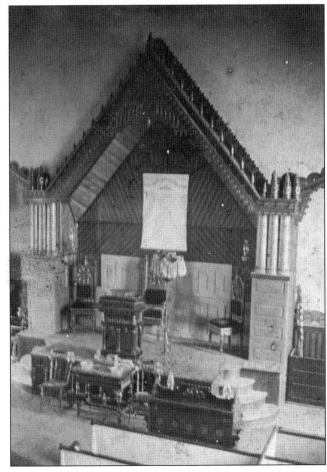

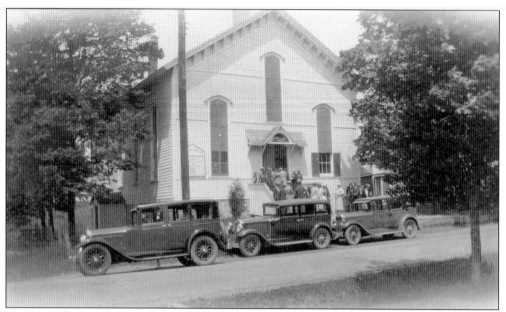

The Amwell First Presbyterian Church, built in 1738, originally stood a mile northwest of its present Reaville site. Anglican minister George Whitefield preached to 3,000 people near the church in 1740, and Dr. John Witherspoon, a Declaration of Independence signer, also stood behind the pulpit. Locals complained the church was too far from a public house where "any victuals or drinks could be supplied," so in 1838, the church was moved to Reaville. Above is a view of the church on a Sunday morning in summer 1932; notice the wooden spokes on the car wheels. Below is a photograph of the minstrel show put on at the Reaville Presbyterian Church in 1908, lit by kerosene lamps at the foot of the stage. These performances were held upstairs in the church for many years. (Both courtesy of Doris Wilcox.)

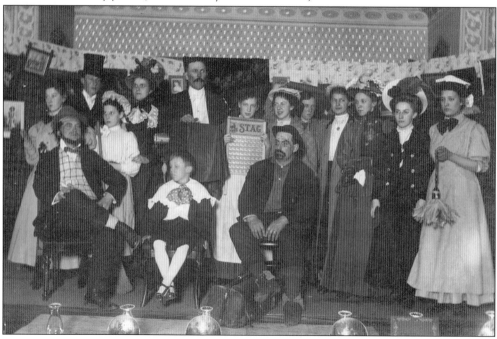

In 1749, German immigrants built a stone church in what is now the Amwell Ridge Cemetery. German-language services were held there until 1811, when the United First Presbyterian Church of Amwell was built across Dutch Lane. The new Larison's Corner Church faced south and had an interior balcony divided into two galleries; the right was reserved for black congregants. In 1869, a north entrance was added facing Old York Road; the seam in the roof distinguishes the additions, which included a steeple and belfry. Pictured below, Sarah and Edwin M. Strong pose after services in 1919; note the horse-and-buggy. The age of the automobile has altered the surroundings. Now that U.S. Route 202/31 passes to the west, Dutch Lane terminates in Old York Road by the church instead of continuing north to old U.S. Route 30. (Below photograph courtesy of Ellen Ramburg.)

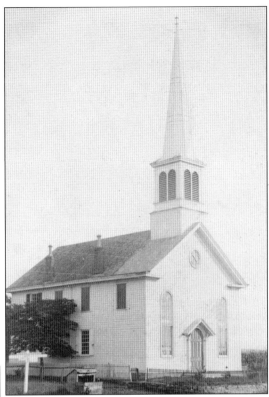

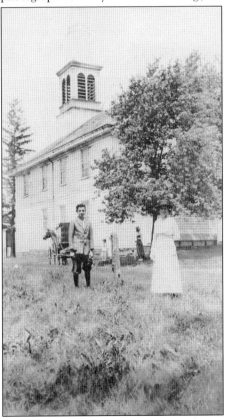

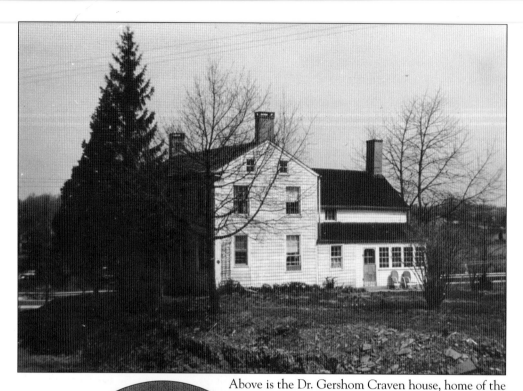

Above is the Dr. Gershom Craven house, home of the physician who attended the Marquis de Lafayette at Landis House in Ringoes when he fell ill during the Revolutionary War. The low portion in the rear of the house was the oldest section; the building was partially destroyed on October 24, 1972, and is no longer standing. It was located where the Ringoes grit yard is now. Rev. Jacob Kirkpatrick lived in the house in the 19th century. Kirkpatrick, pictured to the left, served the United First Presbyterian Church from 1810 to 1865, an astonishing 55 years. During this time, he preached 11,000 sermons, conducted 900 funerals, and married 705 couples. Kirkpatrick also preached part time at the Reaville and Mount Airy Presbyterian Churches. He died in 1866. (Left photograph courtesy of Kirkpatrick Memorial Presbyterian Church.)

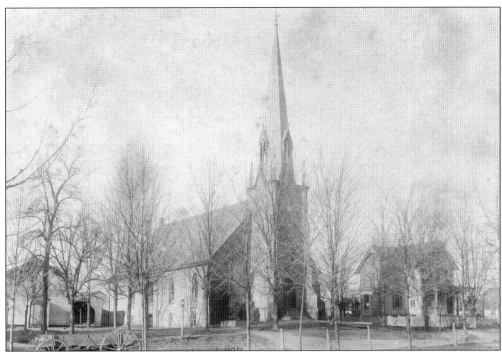

In 1868, the congregation of the United First Presbyterian Church split; 47 members left and built a new church in Ringoes, shown above. They named it Kirkpatrick Memorial in honor of their former minister. It was located next to the lecture hall, left, which had been built to house Sunday school lessons for United First. In 1875, the church bought land to the north and built the parsonage, right. In the background are the sheds that housed horses and buggies; there was also a platform along the street to allow ladies to disembark from their buggies easily. Below is an interior view of Kirkpatrick Memorial Church illuminated by large kerosene chandeliers; the photograph predates 1920, when the church was wired for electricity. A 35-star flag (1863–1865) is on display. (Both courtesy of Kirkpatrick Memorial Presbyterian Church.)

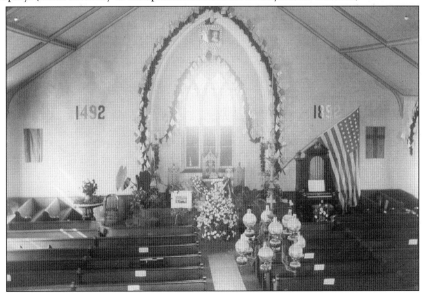

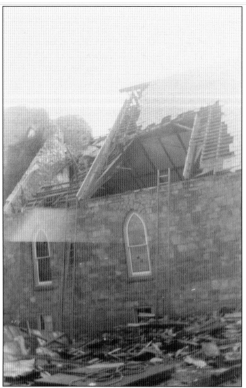

To the left is the exterior of Kirkpatrick Memorial Church is shown after severe storm damage. In November 1950, a hurricane hit New Jersey with 100-mile-per-hour winds. The belfry and steeple crashed to the ground, tearing apart the roof and showering the interior with debris. The manse was also extensively damaged. The congregation succeeded in raising $11,000 for repairs. (Courtesy of Kirkpatrick Memorial Presbyterian Church.)

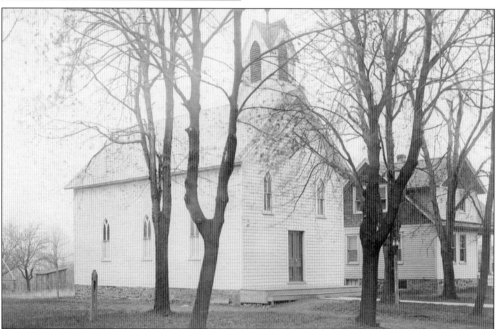

The Ringoes Baptist Church, above, stood on the southern corner of John Ringo Road and Larison Lane. It was built in 1868. Dr. Cornelius Larison and his brother A. W. Larison were instrumental in organizing the congregation and building the church; A. W. Larison became one of the first ministers. (Courtesy of James Walker.)

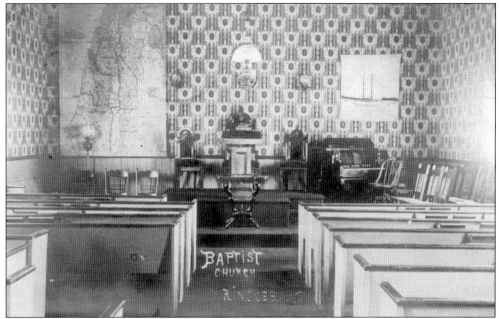

Ringoes Baptist Church flourished in the late 1800s and early 1900s with over 100 members. Its membership slowly declined in the 1920s, and the building was torn down in 1936. Above is a view of the interior before the church was razed. (Courtesy of James Walker.)

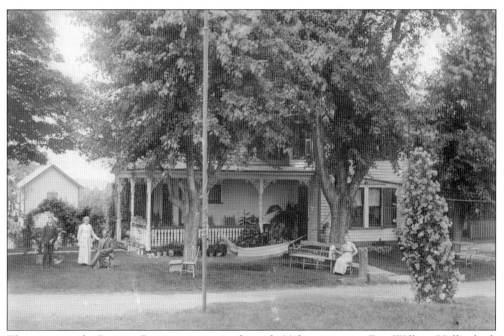

The most popular Ringoes Baptist minister in the early 20th century was Rev. William Hollinshed. He and his wife lived in a manse on Wertsville Road in the Unionville area of East Amwell. The house still stands. Pictured above, Reverend Hollinshed is seated on the left with his wife standing beside him in front of their house, in 1918. (Courtesy of Paul Kurzenberger.)

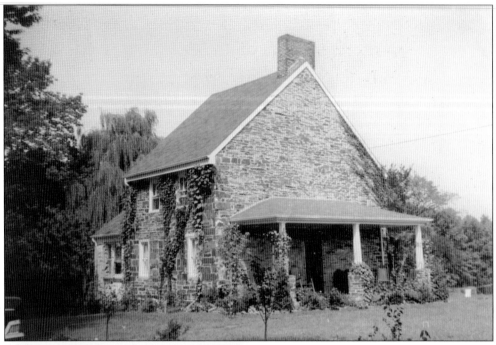

Jacob Birdsall owned this Mountain Road home in the 1750s when it served as a meetinghouse for Quakers. The Quakers were early social activists in Amwell, opposing war and the keeping of slaves. Sometimes its own members ran afoul of Quaker code of behavior as when Henry Coate chose to be expelled in 1759 rather than forego drinking and card playing. The house is shown as it appeared in 1958.

East Amwell's Catholic residents attended church in several nearby communities, including Hopewell and Bound Brook. Sophie Kuznian moved from Poland to Bound Brook and then to East Amwell. She is shown here dressed for her first communion, just before she moved to East Amwell. In 1944, she married Stephan Cvetan, and they owned a farm on Saddle Shop Road. (Courtesy of Jani Collins.)

This stone building has nourished both mind and body. Built in 1811 as the Amwell Academy, which closed in 1830, it housed Dr. Cornelius W. Larison's Seminary from 1869 to 1881, and Polly L. Blackwell's school from the end of the 19th century through 1907. Several restaurants have served meals here since the 1960s; currently it is home to the Harvest Moon Inn.

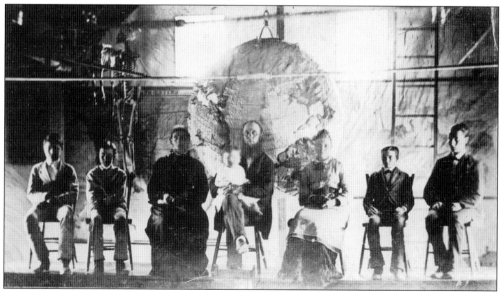

According to Larison's Seminary pamphlet, the school would "cultivate reasoning powers of the students and fit them for the cheerful and conscientious discharge of their duties for life." Larison's wife, brother, and sister were all teachers. Larison firmly believed in hands-on learning; students studied geology and natural sciences in the field. Pictured here, Larison sits with seminary students in front of a 5-foot relief globe used to teach geography.

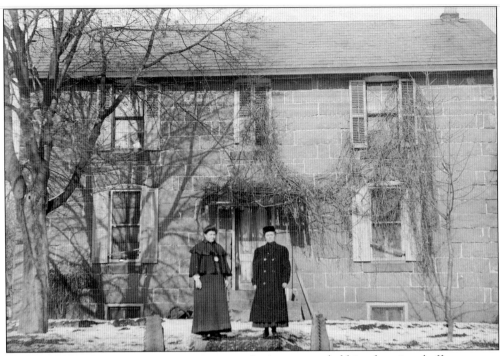

THE

FONIC SPELER AND SYLABATER;

—DESIND AS AN—

AD IN ACQWIRING A NOLEG

—OV THE—

FUNDAMENTAL PRINCIPLS

—OV THE—

ENGLISH LANGWAG.

BY C. W. LARISON, M. D.,

PRINCIPAL OV THE ACADEMY OV SIENC AND ART AT RINGOS, N. J.
FORMERLY PROF. NATURAL SIENC IN THE UNIVERSITY AT LEWIS-
BURG, PA.; ATHUR OV ELEMENTS OV ORTHOEPY; THE
TENTING SCOL, SYLVIA DUBOIS, &c., &c.

RINGOS, N. J.:
C. W. LARISON, PUBLISHER OV WURKS IN FONIC ORTHOGRAPHY.
1883.

Larison expanded his educational efforts by opening the Academy of Science and Art in this stone house on Larison Lane in Ringoes. His offices were on the first floor, with classrooms on the second. This building also housed his Fonic Publishing House, which published writings—mostly his own—in the revised, phonetic spelling format he championed. His phonetic publications included his *Fonic Speler and Sylabater*, whose 1883 frontispiece is reproduced below; *Ringos*, a magazine on local history published from 1889 to 1890, which went out of business after 12 issues, because it had only 44 subscribers; and *Silvia Dubois: a Biografy of the Slav who Whipt her Mistress and Gand her Fredom*, based on conversations with local ex-slave Sylvia DuBois, then in her 90s. (Above photograph courtesy of Hunterdon County Historical Society.)

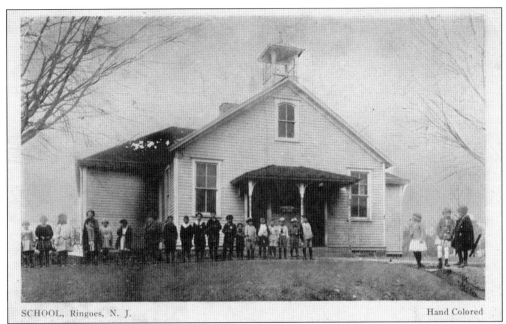

Local legend holds that George Washington visited the first Ringoes school, held in a log cabin. Another school was built in 1854 next to the old Amwell Academy. This school building was moved to Wertsville Road and turned into a blacksmith shop when the two-room school pictured above was built around 1900. Below is a class portrait from Ringoes District No. 103, taken around 1912. Teachers Miss Squires and Mr. Floyd Brotzman are shown with students. From left to right are (first row) Arthur Harvey, Bill Young, Frank Polhemus, Stewart Salter, Lena Stout (Larison), and Laura Titus; (second row) Kenneth ?, Monroe Schillinger, Howard Dillip, Busby Salter, Myrtie Parker (Hockenbury), and Evelyn Polhemus; (third row) Marcia Holcombe, Ada Holcombe (Fisher), Mary Strimpel (Cronce), Elizabeth Case (Edmonds), Katherine Salter, and Reba Hunt (Conover). (Below photograph courtesy of Irvin Hockenbury.)

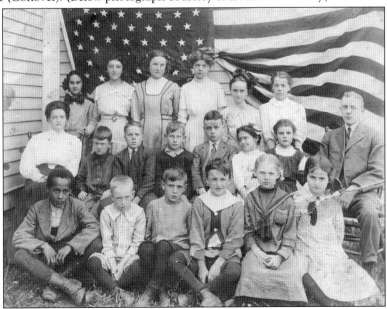

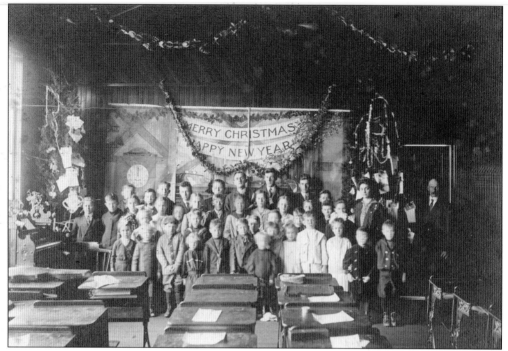

This photograph shows the left side of the Ringoes two-room schoolhouse, known as the "big side" because grades five through eight studied there. The students are posing with their Christmas decorations for a winter class portrait, around 1915. Their teachers were Miss Helen Sargent and Mr. Wolverton.

All the East Amwell schoolhouses had a coal or wood stove, boys and girls outhouses, a bell, and a water pump. Pictured here, two boys vigorously pump water at the Ringoes School. Former students say they froze in the school in winter, for many students the only season in which they attended school regularly. Farm chores kept many students busy at home in the spring and fall. (Courtesy of Ellen Ramberg.)

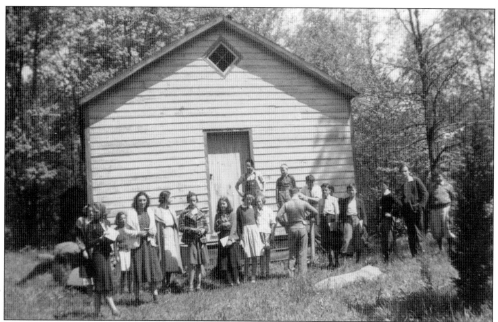

The first school erected in the Sourlands was built in 1812 and called the Mountain School. In 1863, it was replaced by the Mountain Grove School No. 101. Pictured above, students who attended Mountain Grove School gathered in 1939 for a reunion at the schoolhouse. Pictured below, teacher Mrs. Craft rests after shoveling snow. Most teachers boarded with local families because the mountain was often inaccessible during the school year. After the school closed in 1914, students had to travel to Wertsville's two-room school; they would walk to Zion Road, where a horse-drawn bus picked them up. The school building was converted into a house but abandoned after another house was built on the property. It is still standing on the corner of Lindbergh Road and Burd Lane. (Both courtesy of Alberta Flagg.)

MRS. CRAFT

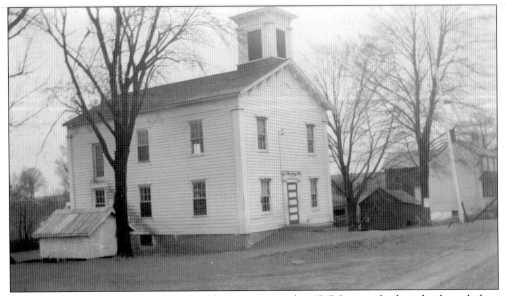

The first Wertsville school was a log building, constructed in 1747. It was rebuilt and enlarged, then moved to where Peacock's General Store is now located in 1846. The new schoolhouse pictured here was built in 1853 and became known as Wertsville District No. 100. It had two rooms; the large room upstairs was often used for community events. The building is now a private residence. (Courtesy of Deborah Lentine.)

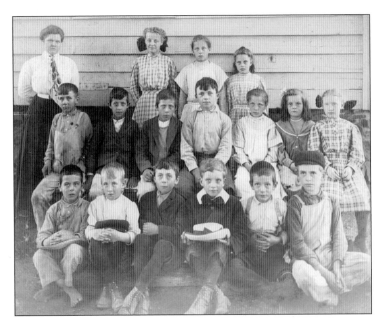

This *c.* 1910 picture shows Wertsville School teacher Florence Zang with her pupils. They include children from many families that remain well known in East Amwell, including the Manners, Higgins, Cronce, Wyckoff, Hockenbury, Van Lieu, Everitt, Stryker, Chamberlain, La Rue, Sutphin, Welisewitz, Whitehead, Rafalowski, and Hausenbauer families.

D. L. Gulick took this photograph of the Unionville School, with students and teachers gathered in front, around 1883. The schoolhouse was built in 1858 on lands leased from Joseph Greene Quick and was the third school in the Unionville area. The original date stone, pictured just below the attic window, is preserved at East Amwell School. The building burned in 1958 during a planned Ringoes Fire Department drill.

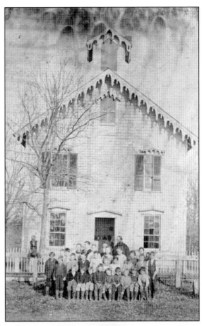

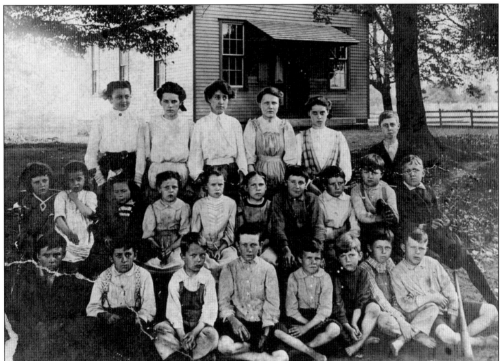

Posing in front of the Reaville schoolhouse are, from left to right, (first row) unidentified, Winfield Case, Arthur Sutphin, Ewing Cole, Clifford Cole, two unidentified, and Earl Pierce; (second row) Miriam Case (Hipple), unidentified, Mary Taylor, Mary Cane, Martha Cane, Marie Swarer, three unidentified, and Oscar Rowe; (third row) Olive Cronce (Snyder), Helen Pierce, teacher Laura Groff, Alice Cane Manners (Cronce), Anita Kisz, and Heber Kisz. The building is now the Reaville Sportsmen Club. (Courtesy of Doris Snyder.)

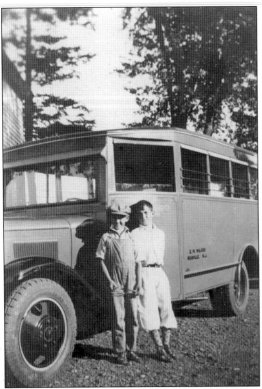

Rodney (left) and Earl Wilcox pose in front of the c. 1934 bus, which their father Seward drove to Flemington High School. The first motorized bus for high school students rumbled into East Amwell 20 years earlier. It lacked a roof and was actually a farm wagon attached to an automobile chassis. (Courtesy of Doris Wilcox.)

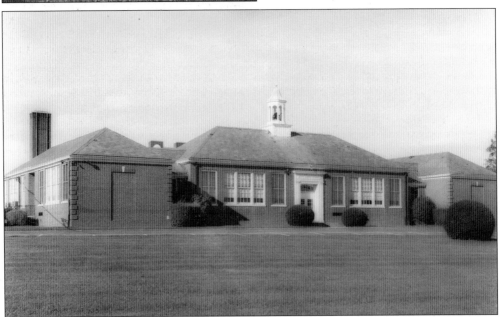

Along with the Wertsville and Ringoes schools, Unionville closed when the East Amwell Consolidated School was built in 1939. Local farmers surreptitiously installed the Unionville School bell in the new school's cupola, shown above, sneaking onto the construction site on a weekend to do so. The consolidated school was a Federal Public Works Administration (PWA) project. It took 10 months to build and cost $75,000.

Six

FARMING COMMUNITY

The first settlers who came to East Amwell turned to farming for the sake of survival. One of their first tasks was to clear the land to plant crops for themselves and their animals. Their struggles to clear enough land for cultivation were hindered by the dense forest undergrowth and the primitive quality of their equipment, although the forest yielded plenty of wood for structures, tools, and cooking fires.

Initially random breeding and poor care caused deterioration in the animals they brought with them, but they gradually improved their livestock through better breeding and importation of stronger bloodlines from Europe. Interest in quality horses became so great in the early 19th century that exhibitions were held in Flemington and Lambertville.

Despite significant changes in agricultural methods over the centuries, the crops grown in the Amwell area have varied little. Besides such staples as wheat, rye, and corn, early farmsteads had orchards of apples and peaches, which flourished, and still do.

While these farmers considered erosion a serious but unavoidable problem, some tried to combat it by establishing stone breakwaters, fencerows, and strips of grass between cultivated rows. In the 20th century, concerns over the long-term effects of soil erosion on farmland came to a head. In 1935, twenty-one men met at Ringoes and joined the Soil Erosion Service of the Department of the Interior, which later became part of the Civilian Conservation Corps. Their first erosion control project was done on the Fred Totten farm. During the next two years, 150 farmers, owning 10,896 acres, established erosion control and water-conservation methods.

Today East Amwell boasts some of the finest farmland and agricultural practices in the state, and great efforts are being made to preserve the land for future generations.

Yourself and company are cordially

invited to attend

A SOCIAL PARTY,

At the residence of Mr. John H. Totten,

RINGOES, N. J.,

Wednesday Evening, March 18th, 1908.

GOOD MUSIC FURNISHED.

Gents Assessed. Ladies Furnish Cake.

COMMITTEE.

FRED TOTTEN. FRANK MILLER.

Rain or shine.

Shown here is an invitation to a social event at John H. Totten's Ringoes residence in 1908. His son Fred Totten is named on the invitation. A few years later, John moved from this property to the farm that is now Unionville Vineyards, where he lived with his daughter and son-in-law. They purchased the 109-acre farm for $5,000. (Courtesy of June Totten.)

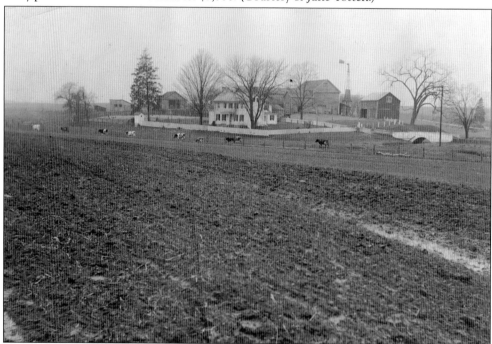

Woodcrest Farm, purchased in 1917 by Fred and Madge Totten and then owned by their son Ken and his wife, June, was predominantly used as a dairy farm. This picture from 1938 shows their cows and many wood outbuildings, most of which have been replaced. Ken Totten served on the New Jersey State Board of Agriculture, and his farm was one of the first to be preserved in East Amwell. (Courtesy of June Totten.)

Throughout the 1940s, many Ringoes Grange Fairs were held in the Tottens' back field. This photograph shows Fred and his wife, Madge, in front of their Pioneer Hybrid Seed booth during the 1940s, probably at the Flemington Fair. Fred Totten was a dealer for Pioneer Hybrid Seed Corn for 40 years. Hybrid corn was first developed for commercial sale in the 1920s; by 1959, 95 percent of U.S. corn crops were grown from hybrid seed. (Courtesy of June Totten.)

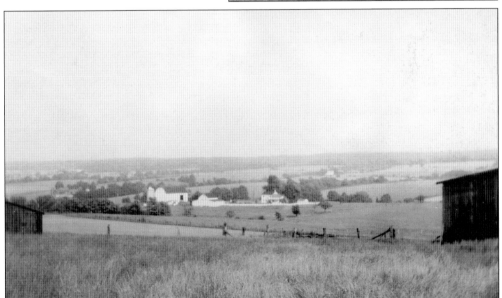

This view of the Amwell Valley shows its lush farms and thriving agriculture in 1950. The photograph was taken from Losey Road across the fields, taking in the farms of Walter Hill and Joe Sowsian.

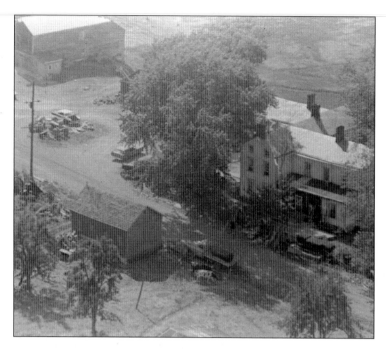

John and Agnes Sowsian purchased this house on 160 acres on Orchard Road in 1925. The farmhouse was built in 1836. The Sowsians sold milk to Harbison Dairy at the Ringoes Railroad Station and supplemented their income with an extensive egg route. One day each week they drove their eggs to Brooklyn; another day each week they drove to Jersey City, Bayonne, and West New York to make egg deliveries. (Courtesy of Bernice Sowsian.)

John and Agnes' son Joe Sowsian married Bernice Cortina from Trenton, New Jersey. When Bernice arrived in the country in 1954, she was shocked at the primitive conditions. Five-year-old John Sowsian, one of Joe and Bernice's five children, is shown here, sitting on his father's tractor around 1968. (Courtesy of Bernice Sowsian.)

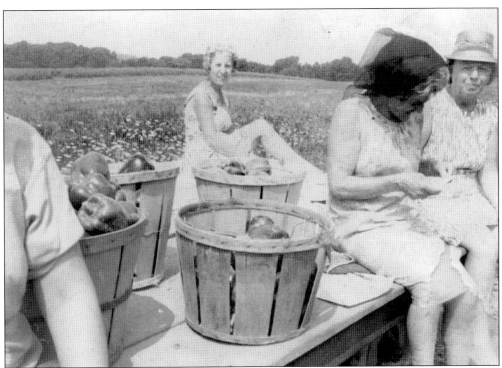

As farming began to change, the Sowsians switched to wholesale farming. First they raised tomatoes for Stokely-Van Camp in Trenton, until the company moved. Then they raised sweet corn and had a U-Pick-It farm with tomatoes, eggplants, and peppers. This photograph shows a group of women with baskets of Sowsian produce, enjoying the sunshine. The Sowsian farm is now preserved through New Jersey's Farmland Preservation Program. (Courtesy of Bernice Sowsian.)

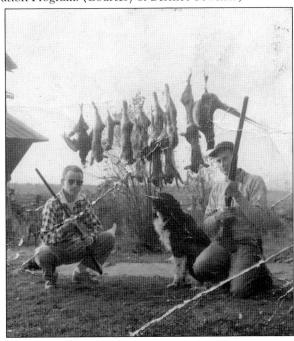

In the 1940s and 1950s, small game such as pheasants and rabbits were abundant in the Amwell Valley. Deer were rare enough that shooting one merited a mention in the local newspaper! This photograph shows Ben Cortina of Trenton, New Jersey, (left) with his brother-in-law Joe Sowsian on the Sowsians' farm, after a successful morning hunt. (Courtesy of Bernice Sowsian.)

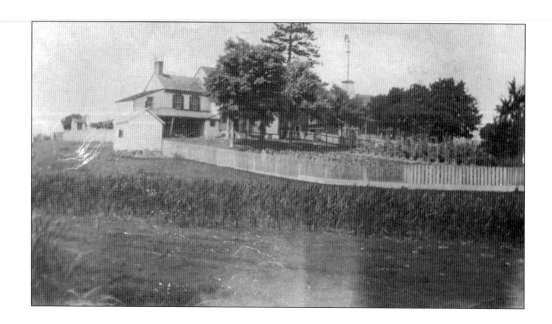

Milton and Ida Mae Sutphin's farmhouse on Dutch Lane is shown above, in 1918. Milton and Ida raised their three children on the farm: Pauline, Kathryn, and Milton Jr. The house looks very much the same today. The farm is now owned by the Reiter family. Pictured below, the Milton Sutphin Farm is shown during the hay harvest, around 1911. Harold Sutphin (left) and a hired hand are loading the hay. Eleven-year-old Pauline Sutphin Bond is driving the team. The wagon would drive down the middle of windrows, and the hay loader on the back would kick the hay up into the wagon, where the men on top would push it forward. (Both courtesy of David Bond.)

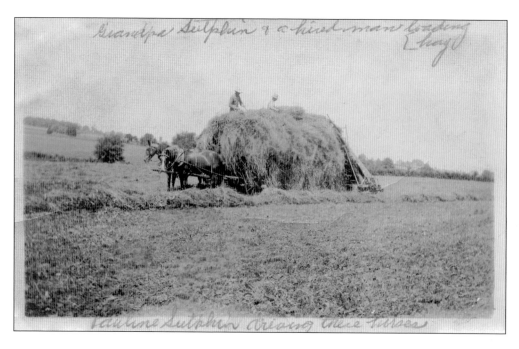

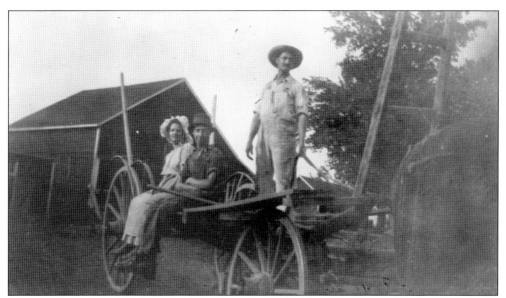

Pictured above, a woman and two men—possibly Pauline, Milton, and the hired hand—relax on the Sutphin hay wagon. The Colonial post-and-beam frame barn in the background burned to the ground on Halloween night in 1948. By that point, the Reiter family owned Twinbrook Farm. Unfortunately their herd of dairy cows was trapped inside the burning building and perished. In 1949, carpenter Walter Mills of Ringoes constructed a 134-foot-long barn shown below to replace it. The new barn's distinctive arched roof is built with laminated wood beams. Mills is climbing the ladder, and Robert Reiter is on the ground, grabbing the block. (Above photograph courtesy of William Reiter; below photograph courtesy of Roger Reiter.)

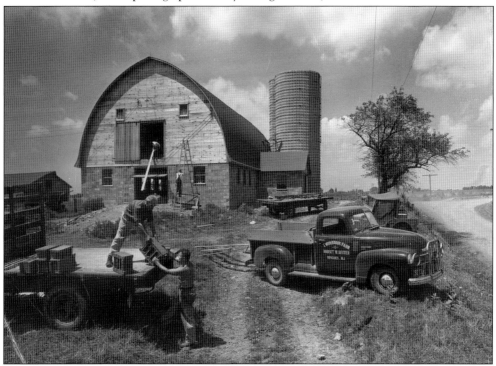

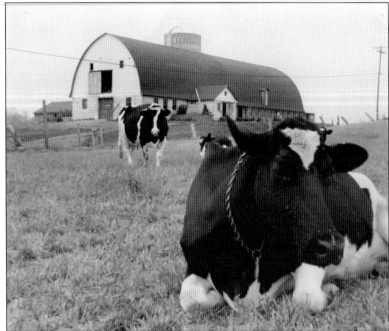

Dairying was in its prime in the Amwell Valley from the 1930s through the 1960s, when cow farms began to be superseded by horse farms. This photograph shows "Pretty Eyes" and "Number 7" at the Reiter Farm on Dutch Lane, formerly the Milton Sutphin Farm. (Courtesy of William Reiter.)

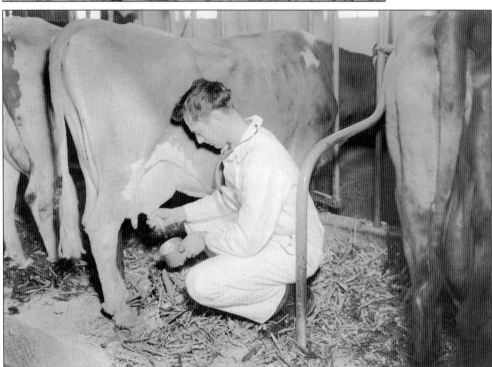

During the Depression, veterinarian Douglas Harrison lived with his wife in a chicken coop on his family's farm in Bowne Station until he could afford his own home in Ringoes in 1938. As East Amwell was a dairy community, Dr. Harrison practiced general veterinary medicine but specialized in cows; here he is taking a milk sample for testing. He practiced until his death in 1974. (Courtesy of William and Barbara Harrison.)

Anton and Pauline Cvetan settled on Saddle Shop Road in the mid-1920s, raising cows and chickens. By the mid-1930s, their sons Joe and Steve Cvetan had started the Cvetan Brothers Company. They had a truck farm that raised tomatoes for Campbells and Del Monte. They also took their produce to the markets in Newark, where they got 10¢ a basket for tomatoes during the Depression. By the late 1950s, they had opened a farm stand on U.S. Route 31. Pictured to the right, Anton's truck is filled with baskets of produce to take to the markets in 1937. The photograph below shows the Cvetan Brothers truck a decade later. (Both courtesy of Jani Collins.)

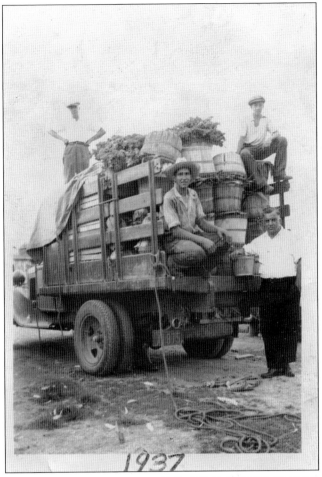

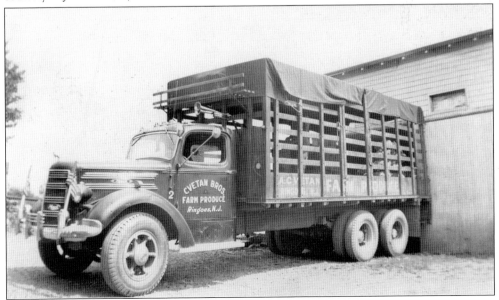

Justyn and Susan Wielenta came to East Amwell directly from Poland, settling on Wertsville Road in the late 1920s. They did general farming: raising cows, pigs, and chickens. Mr. Wielenta raised chicks and had an egg and chicken route in Brooklyn, New York. Today their farm has been preserved through New Jersey's Farmland Preservation Program. The photograph above shows the farm in winter, before the barn on the left burned in 1950. Pictured below, the Wielentas tend to one of their cows in June 1939. The property is now occupied by the fourth generation of Wielentas in East Amwell. (Both courtesy of Ronald Wielenta.)

The Manners family is one of the oldest families in East Amwell, along with the Higgins, Prall, Stout, Stryker, Sutphin, and Wycoff families. The original Manners homestead was a stone house on the property shown above. The stone house no longer exists. The farm is located above Wertsville Road, just off Lindbergh Road, and is now owned by Bryce Thompson. The house and barn on the far right still stand, but a disastrous fire consumed the middle barns. More recently, the Manners family farmed Old Bridge Farm at the corner of Wertsville and Manners Roads. Pictured to the right, Van Dyke B. Manners is shocking wheat in about 1915, at Old Bridge Farm. (Right photograph courtesy of Deborah Lentine.)

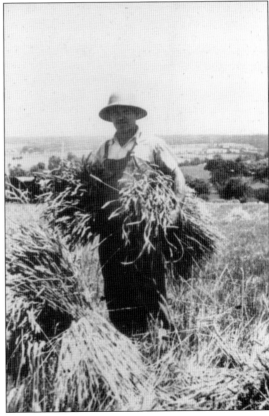

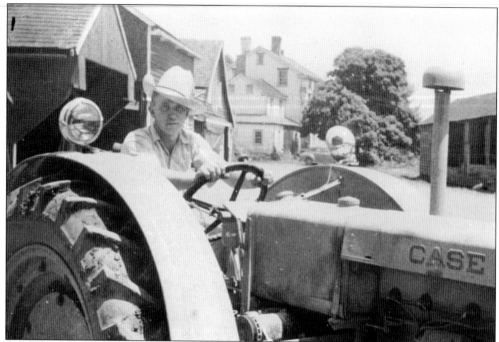

Ken Manners, pictured here on his tractor in 1940, raised thoroughbred racehorses and dairy cows on Old Bridge Farm. The loft in his main barn was so big they held community square dances there in the 1930s and 1940s. Ken's son, Dyke Manners, died in Vietnam. Honoring this veteran, East Amwell Township renamed Manners Road after him in 1970. (Courtesy of Deborah Lentine.)

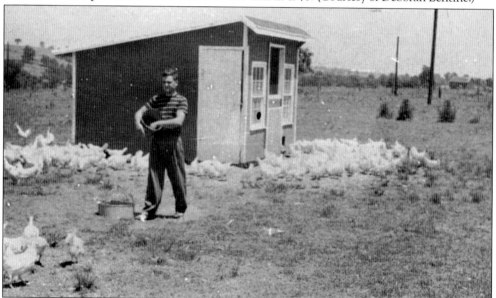

Robert Manners feeds chickens on another Manners family farm, around 1943. Originally called Rutland Farm after an ancestor, the Duke of Rutland, this Manners farm is known today as Terraceland. Terraces were added in the 1940s to reduce soil erosion and protect water quality. For this and other conservation efforts, Terraceland was designated as the first river-friendly farm in New Jersey in 2006. (Courtesy of Deborah Lentine.)

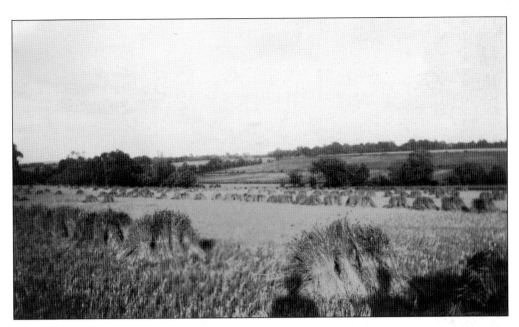

Prior to the introduction of combine harvesters, wheat was cut by hand, tied into bundles, and then placed into shocks. The picture above was taken around 1900 along Back Brook Road, in the section now called Welisewitz Road. It shows shocks of wheat standing in the field after harvest. By the late 1920s, hay was being cut by a sickle bar mower and raked into windrows with a dump rake. It still had to be pitched onto the wagon by hand. Pictured here, local resident Jack Kanach's great uncle Leon Kowalski (left) and his grandfather Julian Kowalski (right) are loading hay. The man on the wagon was a hired hand. The Kanach families moved into the Amwell Valley in the early 1920s. (Above photograph courtesy of Linda Marshall; below photograph courtesy of Marilyn and John Kanach.)

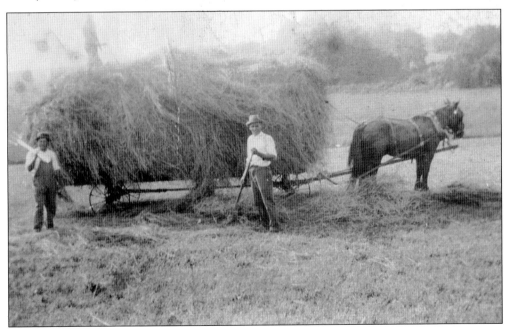

The Culver family moved into East Amwell on South Hill Road in the early 1950s. They had several pet goats, which they kept for milk. Pictured here, from left to right, Tina, Andy, Barbara, Mildred, and Jon keep watch on the latest addition to their family. (Courtesy of Anthony Q. Culver.)

Tractors greatly reduced the time and physical labor for a farmer and his family. Pictured here, an early tractor is hooked up with a leather belt driving a stationary corn sheller in a barn near Reaville. (Courtesy of Irvin Hockenbury.)

Charles Bond, an East Amwell farmer, sold Agrico Fertilizer at the Ringoes Lumber and Feed Mill located at the railroad station in Ringoes. This was an advertisement that was developed locally in 1947, showing bags of Agrico sitting on a grain drill getting ready to plant wheat. Agrico used the image in the company's national advertising campaign. (Courtesy of David Bond.)

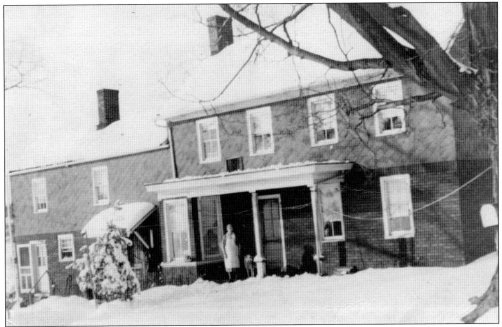

The Sutphins are a very old Amwell Valley family, who owned farms and residences all over East Amwell. This photograph shows the Lewis Sutphin farm on Back Brook Road, around 1935. Della Sutphin is on the porch with her dog Ladie. In 1970, East Amwell Township changed the name of this section of Back Brook to Welisewitz Road to honor local veteran Andrew Welisewitz, who died in World War II. (Courtesy of Linda Marshall.)

This was not a good day. Lewis C. Sutphin flipped his tractor on the Back Brook farm in the summer 1943, going down an embankment. Fortunately he only slightly injured his leg. The tractor was hauled back up and only sustained minor damage. The photograph shows the tractor just before they began to pull it up. (Courtesy of Linda Marshall.)

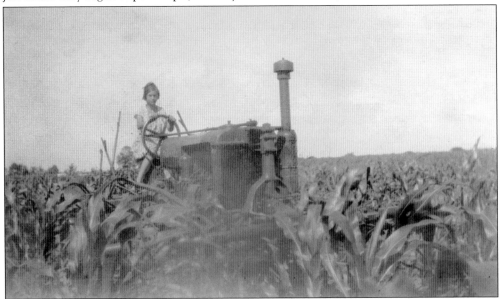

Pictured here, Catherine Sutphin Fisher Marshall learns to drive a tractor on her father's farm on Back Brook Road, around 1935. As this and other photographs demonstrate, women have always played an active role in East Amwell agriculture. Local farms were operated by the entire family, and children became involved in animal husbandry and crop cultivation at an early age. (Courtesy of Linda Marshall.)

In April 1923, a great tornado swept through the eastern portion of the Amwell Valley. It traveled along Amwell Road, through Reaville to Clover Hill, and then veered back along the Back Brook. The tornado affected many of the farms east of Ringoes. Above, we see what was left of the barn on the Sutphin Farm after the tornado struck. The photograph below shows the Williamson farm on the south side of Welisewitz Road, just after the tornado. The house survived but most of the barns and outbuildings were destroyed. The debris was stacked in large piles, as seen here. (Both courtesy of Linda Marshall.)

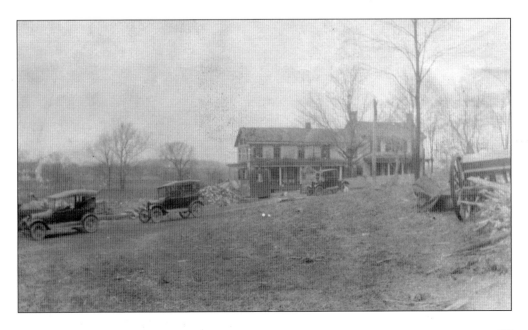

Charles W. Prall Sr. is shown here on his grandfather William Bellis Prall's farm on Back Brook Road, around 1915. Charles later graduated from Rider College but was unable to find a job during the Depression and eventually became a chauffeur for Dr. McCorkel in Ringoes. McCorkel was the attending doctor for Bruno Hauptmann, so Charles drove him daily to the "trial of the century." (Courtesy of Irma Fuhr.)

This is the farm of William Bellis Prall Sr. on Back Brook Road, around 1905. Prall owned two adjoining farms, but the house and a tenant house on one of the properties burned. The woman holding the horse is Elizabeth Prall. Her husband, William Prall Jr., their daughter Elizabeth Prall (Bodine), and William Prall Sr. stand in the drive. (Courtesy of Irma Fuhr.)

Adolph Stern, president of the American Psychiatric Institute, purchased this farm on Cider Mill Road with his wife, Mamie. They lived in New York City but enjoyed their country home on weekends. They also had a rental house on the property. The picture above shows three children in a sulky, a two-wheeled cart, in front of the Stern's house around 1949. From left to right, they are Wayne Fisher, Linda Marshall, and Ted Lane. The house was later owned by Winchester Forgey, principal of the Flemington Raritan School District. Horse travel remains popular in the Amwell Valley, which is intersected by a network of trails and is now home to numerous horse farms. Pictured below, Louise Hunter rides her horse Dinah home from a birthday party on Cider Mill Road in 1954. Her family lived next to the Sterns. (Both courtesy of Linda Marshall.)

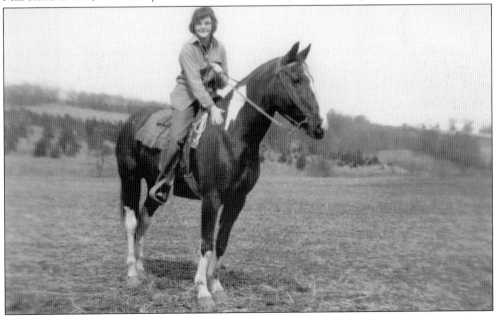

The first Van Doren family farm was located at the corner of Cider Mill Road and Welisewitz Road. Pictured here, Fred Van Doren Sr. stands on the farm with his daughter Dorothy and his son Abram, around 1920. This farm now belongs to the DuFosse family. (Courtesy of Hermione Van Doren.)

In the mid-1930s, the concept of artificial insemination became a reality in Clinton, New Jersey. In this photograph, Hunterdon County agricultural agent B. F. Ramsburg (left) stands with Abe Van Doren, his cow, and her new calf, around 1938. The calf was the second one conceived by artificial insemination in the United States. (Courtesy of Hermione Van Doren.)

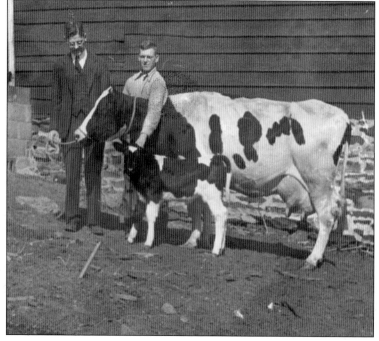

Fred Van Doren stands next to his *c.* 1936 John Deere "D" tractor. Fred's grandfather gave him the tractor when he was only eight years old. He used it for farming and tractor pulls at the Flemington Fair. It still works, proving "nothing runs like a Deere." (Courtesy of Hermione Van Doren.)

Farm buildings are reusable! In 1967, this corncrib from the J. C. Case property is being moved to a new site, across Amwell Road from what is now Cider Mill Estates. The outbuilding was lifted onto two farm wagons and pulled by two tractors driven in tandem by Abe and Fred Van Doren. The corncrib made it to its new location intact. (Courtesy of Hermione Van Doren.)

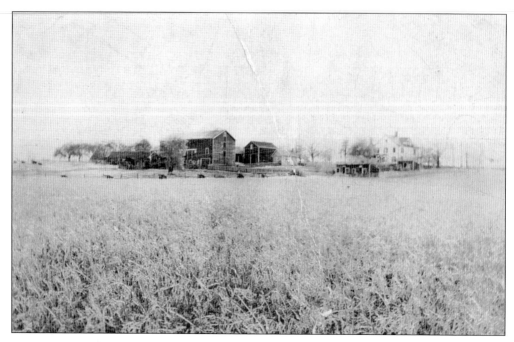

Pictured above, the current Van Doren farm is seen, looking northwest from Cider Mill Road toward Amwell Road. When this photograph was taken in 1920, the farm belonged to the Van Arsdale family. Today every building shown here has been replaced. The main barn burned in 1947. The Van Arsdales raised poultry, especially turkeys (below). The block pump house in the background was ill fated: it blew up due to a faulty compressor, was rebuilt, but burned down again in 1973. (Both courtesy of Hermione Van Doren.)

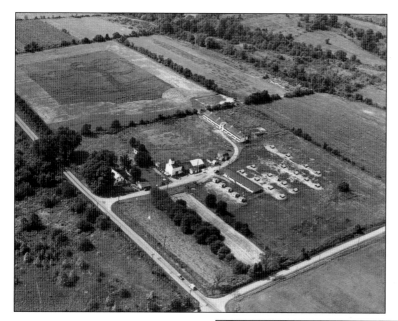

East Amwell had several major poultry farms. Saul Posner moved from Mississippi to East Amwell during the Great Depression. He purchased this farm on U.S. Route 518 and raised chickens. This aerial view, taken during World War II, shows the chicken houses and his feed mill. Today the farm is owned by Tony and Glorianne Robbi. (Courtesy of Glorianne Robbi.)

This nursery advertisement offers 21 varieties of peach trees—guaranteed to be disease free. It dates to around 1927, when U.S. Route 31 was still known as U.S. Route 30. This was after a severe infestation of San Jose scale swept across the state, crippling the peach orchards. Hunterdon County had been the center of the New Jersey peach industry, boasting over 2 million trees by the late 19th century. (Courtesy of Harriet Barrick.)

HUNTERDON COUNTY
Agricultural Society

Admit ONE Person.

1879.

Above is a ticket to the 1879 Hunterdon County Agricultural Society Fair. The society was formed in the mid-1850s to promote good farming practices, new equipment designs, and better animal husbandry. Originally known as the Flemington Fair, the annual event was moved in 2003 to Ringoes and renamed the Hunterdon County 4-H and Agricultural Fair.

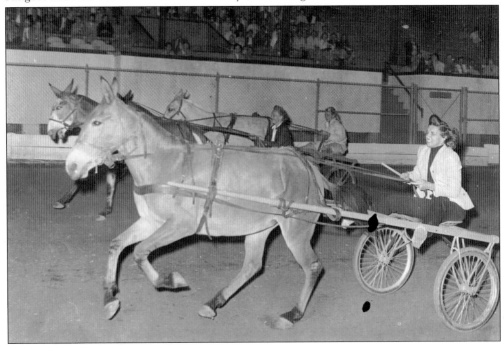

In the 1950s, mule races were held twice a day at the Flemington Fair, from Tuesday through Thursday. A concession owner transported the mules from Trenton, and "volunteers" were invited to participate. Pictured below, Gladys Manners (foreground) races on Farmers Day, and is winning by a nose. (Courtesy of Deborah Lentine.)

Seven

GETTING AROUND

From planes, trains, and automobiles to horses, donkeys, and tractors—Amwell dwellers employed any means possible to move themselves and their wares from place to place. In the 18th century, horseback riding and the stagecoach were common modes of transportation. Travel could be dangerous: the wolves that attacked farmers' sheep herds in the valley also snarled at travelers passing through. Farmers were paid a bounty to kill off the wolves, and the last one disappeared from local lanes around 1800.

Beginning in 1765, the four-horse coaches of the Swift-Sure line whisked passengers and postal items between Philadelphia and New York along the Old York Road in a quick two-day trip. Philadelphia's elite considered Greenville (now Reaville) Tavern the midway point on their journey to the fashionable spas of Schooley's Mountain in Morris County, New Jersey.

Decades later, the railroad lumbered into Ringoes, bringing prosperity to farmers and business owners in the Amwell Valley. From 1872 to 1929, commuters could hop aboard a train at the Ringoes station and travel to New York City, Chicago, or the Jersey shore. Passenger trains disappeared from Ringoes for 40 years until the Black and Western Railroad revivified the line.

As the 1900s picked up steam, horseless carriages began puffing along town roads. Initially those roads made automobile and motorcycle travel a challenge: dust-choking lanes in dry weather gave way to muddy, rutted paths following summer storms. Continual construction projects improved travel over the years. In the 1960s, the state undertook a massive roadway project for U.S. Route 31, which swung the highway past the heart of Ringoes. Businesses felt the pinch of being bypassed, and the landscape of the community was forever altered.

This 1967 aerial view of Ringoes shows the new jughandle south of Ringoes. Ringoes is on the left, and Larison's Corner is just visible in the top right. Ringoes thrived at the intersection of the Trenton-Easton Turnpike and the Old York Road, which followed the paths of Native American trails and were major thoroughfares for centuries. Old York Road, running from the lower left to upper right of this shot, was the main stagecoach route from Philadelphia to New York, bringing brisk business to the town center. Ringoes blossomed further when the railroad came through; the tracks are shown here at the edge of town in the upper left. When U.S. Route 202/31 was built in the early 1960s, it had a dramatic negative impact on Ringoes' commercial life. The traffic carried along this new artery almost completely bypasses the town center.

Reverend Hollingshed was the minister of the Baptist church in Ringoes. Pictured here, he and his wife are going out for a drive, around 1915. They are pulling away from their house on Wertsville Road at Unionville; an unidentified boy stands nearby. The building to the right housed a water tank over an artesian well.

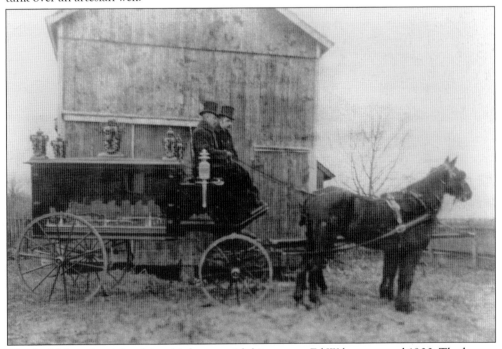

Charles Holcombe, right, drives his hearse with his partner Ed Wilson, around 1900. The hearse is pulled by two horses, Ned and Prince. After visiting the home of the deceased, Holcombe would transport the body to the church for the funeral. Holcombe kept his hearse and horses behind his brother Cal's general store, one building south of the Odd Fellows Hall in Ringoes. (Courtesy of Charles Fisher.)

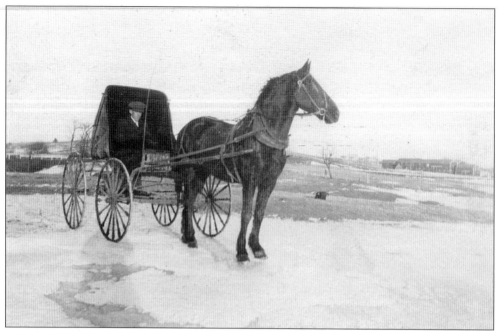

In 1900, Levi Hockenbury looked ready to roll in a buggy pulled by his horse Dick. Buggies offered an inexpensive means of travel and featured folding tops that could be pulled up in inclement weather. (Courtesy of Irvin Hockenbury.)

Of course in an agricultural community, there were always alternative modes of transportation available. In this playful picture, Levi Hockenbury's dog sits atop a donkey, reins at the ready. With him are the Hartpence boys. The picture was taken around 1900 at Hockenbury's farm outside Reaville. (Courtesy of Irvin Hockenbury.)

Edwin Strong operated Cedar Grove Farms, a dairy, first on Back Brook Road and later just south of Ringoes on U.S. Route 179, across from the new fairgrounds. Besides selling milk there, he ran a delivery route through Trenton selling milk, butter, and cheese. As motorized vehicles replaced horses, Strong upgraded his equipment. Pictured above, he is with his child after picking up milk cans from farmers in his horse-drawn cart, around 1890. Pictured below, he is poised on the step of his Ford milk truck, around 1919. (Both courtesy of Ellen Ramberg.)

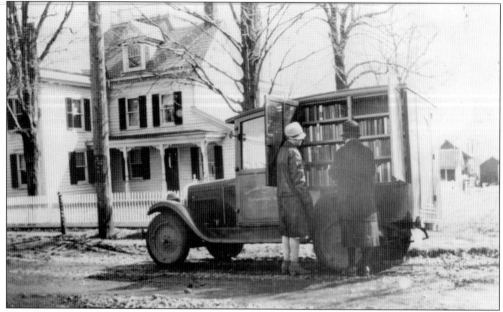

The first Hunterdon County library truck started making the rounds in 1928, visiting homes, stores, churches, town halls, and 88 schools. The truck was a $985 specially designed Chevrolet car and was exhibited at the 1928 Flemington Fair. Pictured here, librarian Elizabeth Thornton Turner (right) checks out books with a woman who might be postmistress Helen Stryker. The county still operates a book mobile.

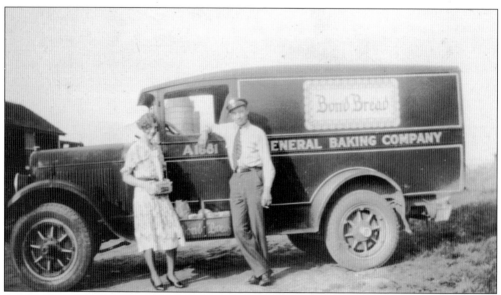

Art Sutphin from Back Brook Road was the local Bond Bread man. He is standing with Ann Byer in front of his delivery truck on May 27, 1931. He died in bed of a heart attack the night this photograph was taken, at only 29 years old. (Courtesy of Linda Marshall.)

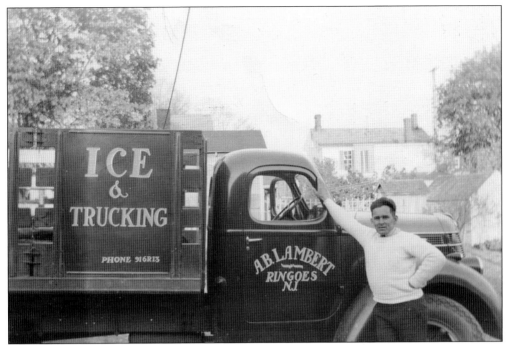

Lambert's Store was across the street from Dave's Sunoco in Ringoes. Besides selling ice cream, newspapers, and cigarettes, Lambert's was noted for its homemade oyster stew and daily menu specials. There was an icehouse behind the store. In this 1941 photograph, Charles "Chief" Lambert stands with the ice truck. Chief later died in an explosion and fire in the house shown in the background. (Courtesy of Teri Angelone.)

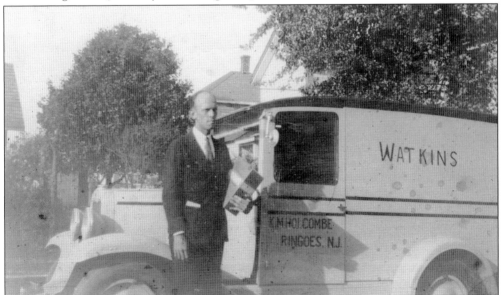

Ken Holcombe was the deliveryman for his father's general store, which is now Carousel Deli in Ringoes. He is pictured here making a local delivery in October 1933. As the writing on his truck advertises, he was also the local Watkins man. Watkins offered pantry, apothecary, and toiletry items through direct door-to-door sales. (Courtesy of Betty Bollin.)

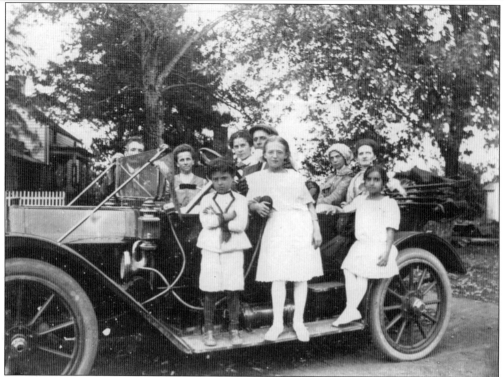

The family car was often the centerpiece for family portraits in the 1910s. Going for a ride in the country in 1912 are Laura and Edwin Strong, standing in the rear; Sarah and Joe Strong in the front seat; Ada Strong and Mable Rynearson in the rear seat; and from left to right on the running board, Ed Strong, Hazel Hunt, and Helen Strong. (Courtesy of Ellen Ramberg.)

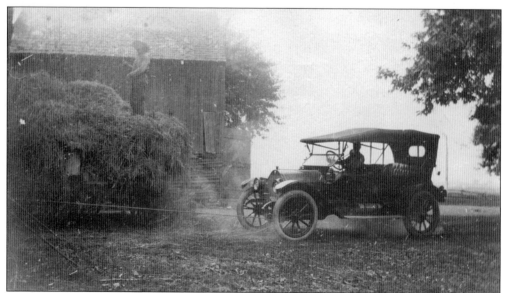

In East Amwell, even cars were pressed into service as farm vehicles! Edwin N. Strong is using his car to work his trolley to pull hay into his haymow, around 1920. (Courtesy of Ellen Ramberg.)

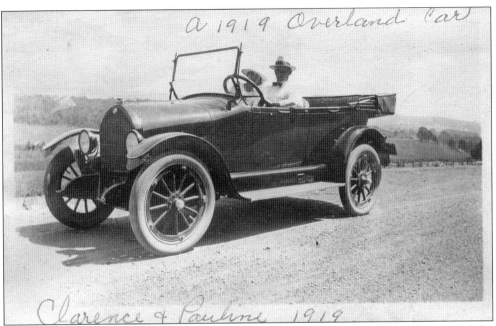

a 1919 Overland Car

Clarence & Pauline 1919

Clarence Bond, right, grew up on the family farm in Delaware Township; his father owned the Ringoes Feed and Lumber Mill. Pauline Sutphin, left, grew up on Dutch Lane. They are shown here courting in Clarence's new 1919 Overland car. The following year they married. (Courtesy of David Bond.)

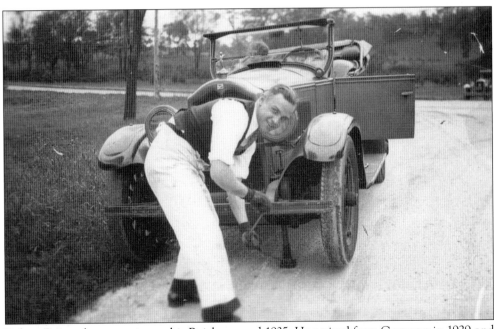

Robert Reiter changes a tire on his Buick, around 1935. He arrived from Germany in 1929 and first lived in Brooklyn. By the mid-1930s, he relocated to a farm in the Amwell Valley. In 1946, he purchased Twinbrook Farm, formerly the Milton Sutphin farm, from the Garboski family. (Courtesy of William Reiter.)

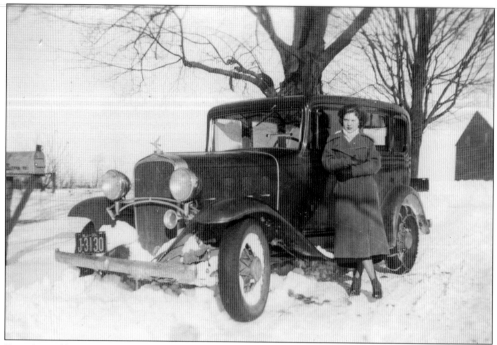

East Amwell winters could be brutally cold, but that would not stop a young beauty like Catherine Sutphin. Shown here in 1936, she is getting ready to step out in her Chevy despite a heavy snowfall. (Courtesy of Linda Marshall.)

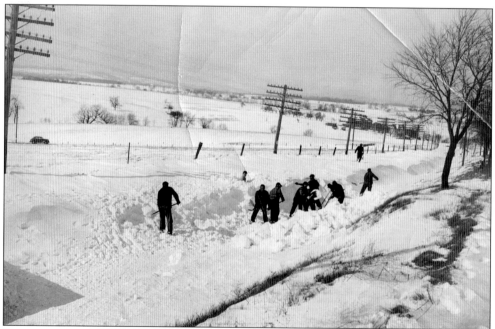

Sometimes even snowplows could not get through. In 1945, Hunterdon County had one of its worst snowstorms in history. This photograph looks east on Old York Road, coming down the hill into Reaville. Farmers had to go out and shovel the road by hand. The boy in the snow pile in the middle is Irvin Hockenbury. (Courtesy of Irvin Hockenbury.)

When the spring rains came, unpaved roads became impassible. As recently as 1927, mud and deep ruts challenged motorists traveling on Amwell Road, which runs from Reaville to New Brunswick. (Courtesy of Hermione Van Duren.)

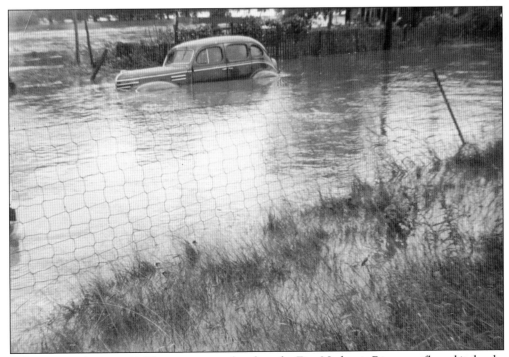

When it rained, it poured. This car was caught when the First Neshanic River overflowed its banks in the mid-1930s, turning the roadway into a new waterway. The picture was taken between Van Lieu's Road and Reaville in the area then known as Hollywood. (Courtesy of Irvin Hockenbury.)

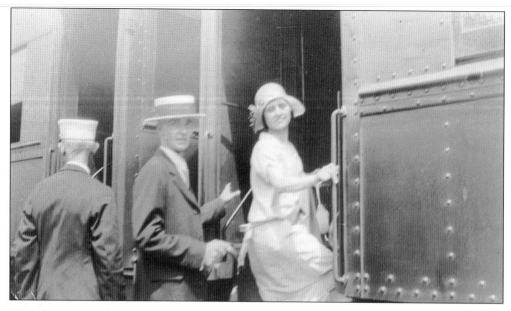

As railroad lines spread throughout Hunterdon County in the 1850s, a town's future growth could hinge on whether the railroad bypassed it. Reaville and Ringoes, Amwell's largest villages, contended for a railroad line; Reaville lost. Pictured above, passengers board a train at the Ringoes station, shown below. People traveled easily and comfortably from East Amwell to the big cities; shopping in Philadelphia or Trenton was simple as was commuting to New York City. Many famous New Yorkers purchased weekend or summer homes in East Amwell, including bandleader Paul Whiteman, the "King of Jazz," who joined the Ringoes Grange. By 1948, when the postcard pictured below was mailed, the station was no longer in use. (Above photograph courtesy of Ellen Ramberg; below photograph courtesy of Paul Kurzenberger.)

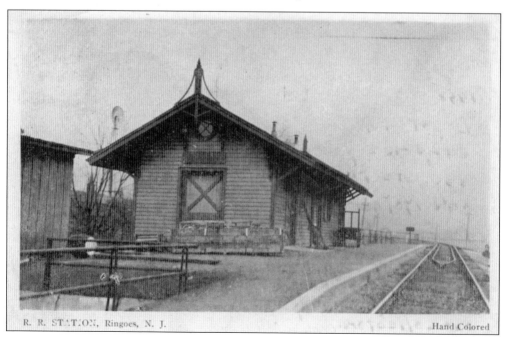

R. R. STATION, Ringoes, N. J. Hand Colored

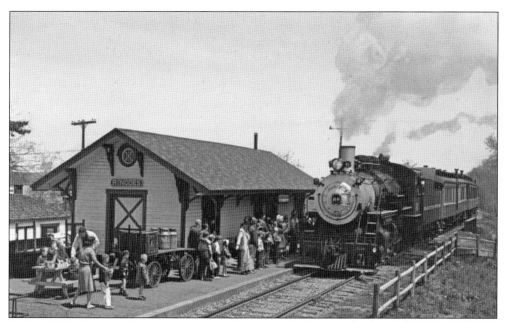

In this 1966 photograph, a tourist train pulling into the Ringoes Railroad Station recalls the age of the steam train. In 1964, Black River and Western Railroad took over the Pennsylvania Railroad line from Ringoes to Flemington and restored this station, built in 1854. As a class II common carrier, they operate tourist trains, serve local industrial customers, and connect to the North American rail network. (Courtesy of Charles E. Danberry.)

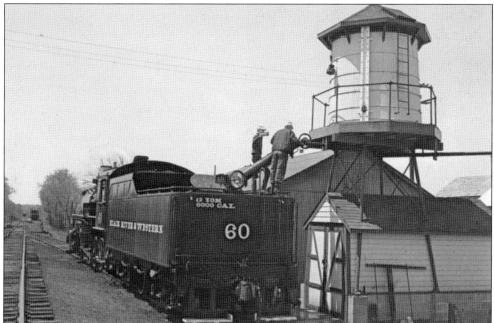

Steam locomotives require a constant supply of water. In this 1966 photograph, one of the tourist trains is taking on water at the Ringoes water tower after coming down from Flemington. The Black River and Western steam locomotives used to continue on to Lambertville, until a trestle was knocked out of use. (Courtesy of Charles E. Danberry.)

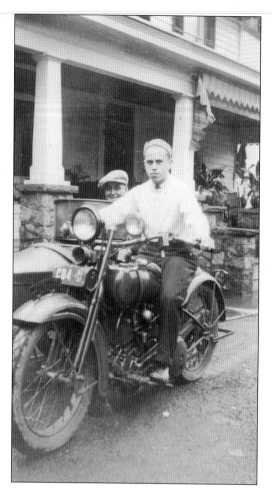

Pictured to the left, East Amwell resident Carey Holcombe is shown in the 1950s on his Indian side-shift motorcycle. He is in front of his grandfather's newly renovated store. In addition to driving cars and motorcycles, many 20th-century East Amwell residents flew planes and had airstrips on their properties. Below is a photograph of Bill Manners, who had just landed his plane on a neighbor's field. Originally from Wertsville, Bill started out dusting banana plantations in Panama but retired from a career with Pan Am. At the far eastern end of Wertsville Road was the Adams-Higgins Airpark. This private airstrip had a hangar and hosted much airplane activity, as well as hot air balloon ascensions. (Left photograph courtesy of Betty Bollin; below photograph courtesy of Linda Marshall.)

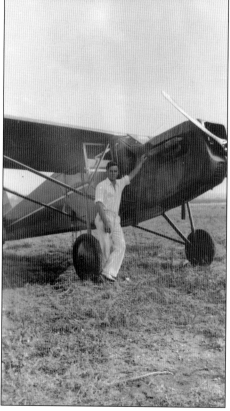

This is a schedule for Golden Arrow Bus Lines, with Amwell area stops including Linvale, Ringoes, and Copper Hill. Beginning about 1900, a trolley ran from Trenton to Pennington and on to East Amwell, ending at the top of the hill by Rocktown. After World War I, motor vehicles became commonplace and buses replaced the trolleys around 1925, running the same route but continuing north to Flemington and Clinton.

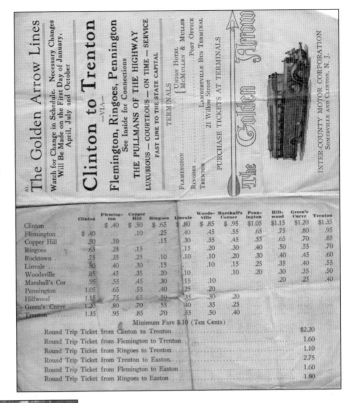

	Clinton	Flemington	Copper Hill	Ringoes	Linvale	Woodsville	Marshall's Corner	Pennington	Hillwood	Green's Curve	Trenton
Clinton		$.40	$.50	$.65	$.80	$.85	$.95	$1.05	$1.15	$1.20	$1.35
Flemington	$.40		.10	.25	.40	.45	.55	.65	.75	.80	.95
Copper Hill	.50	.10		.15	.30	.35	.45	.55	.65	.70	.85
Ringoes	.65	.25	.15		.15	.20	.30	.40	.50	.55	.70
Rocktown	.75	.35	.25	.10	.10	.10	.20	.30	.40	.45	.60
Linvale	.80	.40	.30	.15		.10	.15	.25	.35	.40	.55
Woodsville	.85	.45	.35	.20	.10		.10	.20	.30	.35	.50
Marshall's Cor.	.95	.55	.45	.30	.15	.10			.20	.25	.40
Pennington	1.05	.65	.55	.40	.25	.20					
Hillwood	1.15	.75	.65	.50	.35	.30	.20				
Green's Curve	1.20	.80	.70	.55	.40	.35	.25				
Trenton	1.35	.95	.85	.70	.55	.50	.40				

Minimum Fare $.10 (Ten Cents)

Round Trip Ticket from Clinton to Trenton $2.20
Round Trip Ticket from Flemington to Trenton 1.60
Round Trip Ticket from Ringoes to Trenton 1.10
Round Trip Ticket from Trenton to Easton 2.75
Round Trip Ticket from Flemington to Easton 1.60
Round Trip Ticket from Ringoes to Easton 1.80

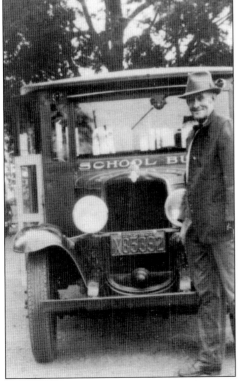

Ed Losey drove this 1930 Chevy school bus for the two-room Unionville School in the 1930s. Ed had a family farm on Losey Road, named for his family. He lost his left hand in a farming accident, but it never slowed him down. He is shown here wearing a metal hook in its place. (Courtesy of Grace Cronce.)

Transportation has many guises, as evidenced by these two photographs. Pictured above, Wayne Fisher is shown outside his East Amwell home in about 1942, pulling his dog Trixie in a wagon hitched to his tricycle; he is clutching her puppy in his arms. Pictured below, the dogs have taken over locomotive duties for themselves. Local pet Pete is pulling another dog on a sled down a snow-covered Ringoes street at the turn of the 20th century. (Above photograph courtesy of Linda Marshall; below photograph courtesy of Betty Bollin.)

Eight

OUR PEOPLE

We travel in the footsteps of those who came before us. John Manners, Runkle, Cornelius Larison, Elizabeth Chamberlain, Abraham Prall, Tunis Quick: these long-dead residents and many others are largely forgotten or only vaguely remembered because of the streets or hamlets that bear their names. They tilled the land, forged iron into horseshoes at the blacksmith shops, and stocked the shelves of the general stores. They delivered the babies and buried the dead.

Along the way, they encountered triumph and tragedy, loves won and lost. A few of their stories have been handed down from one generation to the next. One such tale is Pettinger's Ride.

One summer's day at the Reaville Tavern, young Nancy Pettinger received a letter from her beau urging her to come to Philadelphia to elope. The next day she hopped on the stagecoach for Philadelphia. In Ringoes, the stagecoach squeezed in one more passenger: Harry Thorndyke. The young man, considered a mere idler by some, decided to surprise Nancy by meeting his future wife for the trip south. The girl's father caught wind of the elopement an hour later and hopped on his fastest mare, charging bareback down Old York Road. Between Mount Airy and Lambertville, one of the stagecoach horses toppled over ill. Moments later, the passengers heard hooves thundering up the dirt road as the girl's father arrived. Snakewhip in hand, the father bounded toward the young man. "You'd steal my daughter, would you?" he bellowed. Harry dove into a patch of thorny osage orange, but not before the father's rawhide whip found the young man's backside.

Many things change over the years, but East Amwell's greatest asset will always be its people. It is one of those rare communities where the neighbors know one another, where borrowing a cup of sugar or delivering a home-baked cake to a new neighbor is not a cliché. It is a town where people help out when you are sick and care when you die.

The Ringo family burial plot was west of Kirkpatrick Memorial Church, bounded by a fine stone wall. As the wall crumbled, the stones were used to build the church lecture room. In 1932, local citizens restored what was left of the cemetery and erected this memorial. Although most Ringo descendents moved to Kentucky in the 1820s, relatives periodically make the pilgrimage back to celebrate their roots. Pictured here, Mary Ringo Walker Harper, age 96, visits in 1962.

Henry Landis, saddle maker and father of 24 children, built the stone Ringoes house where the Marquis de Lafayette recuperated during the Revolutionary War. The Landis family cemetery north of Kirkpatrick Memorial Church contains the oldest known headstone in East Amwell, marked "WW 1739." Pictured here is the gravestone of Landis daughter Rebecca, who was buried in the Landis plot next to her husband John Runyan in 1850.

When news of the Klondike Gold strike reached America in 1897, numerous Amwell residents headed to Alaska. These four local prospectors had their photograph taken in Seattle when they returned east. From the left to right are (first row) O. P. Chamberlin Jr., and Bernard G. Volk; (second row) William A. Abbot, who later became the editor of the *Hunterdon County Republican*, and Henry B. Quick.

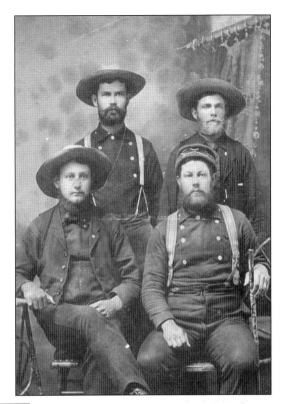

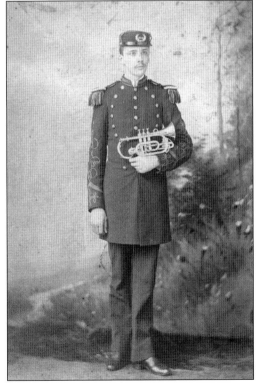

Charles Holcombe, member of the Ringoes Cornet Band, poses here with his cornet around 1890. Charles (1867–1954) was the local mortician and later opened the Holcombe Funeral Parlor in Flemington. His brother Calvin owned the store in the Odd Fellows Hall. (Courtesy of Charles Fisher.)

These unfortunately unidentified, dapper young locals posed for this tintype around 1880. The picture was included in an album passed down to Reaville resident Doris Snyder. The tintype process, invented in 1853, permitted rapid development of photographs. Photographers set up tents at county fairs and other events, where customers could sit for a photograph and walk away with a finished image after just a few minutes. (Courtesy of Doris Snyder.)

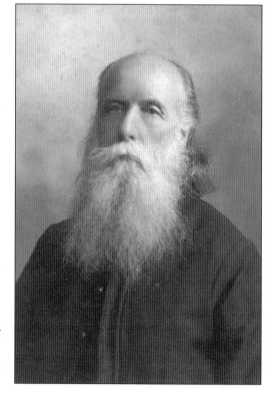

Dr. Cornelius W. Larison, shown here, was one of East Amwell's most famous men and a true character. Born in 1837 in Delaware Township, he began his career teaching at several local schools including Flemington High School. After completing his medical degree in 1863, he practiced medicine out of the Washington Hotel in Ringoes. He later ran his Seminary, Academy of Science and Art, and Fonic Publishing House in town.

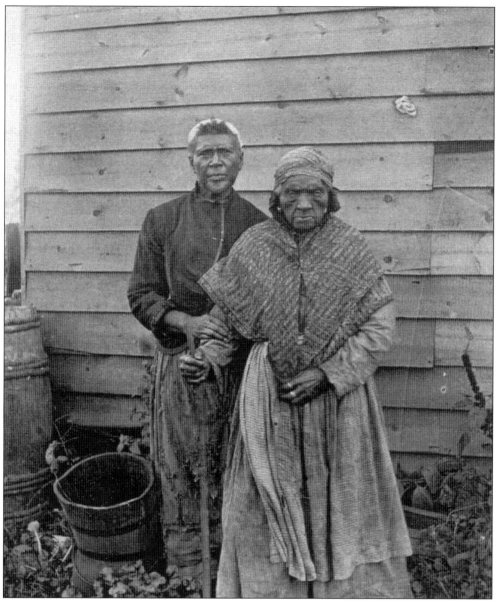

Sylvia DuBois, pictured with her daughter, was born into slavery in the Sourlands around 1788. Her abusive mistress beat her regularly, once fracturing her skull with a shovel. Sylvia fought for her freedom, literally: when her mistress hit her in a crowded Pennsylvania tavern, Sylvia struck back. After this incident, her master freed her. Carrying her baby, Sylvia walked 152 miles to return home. She inherited Put's Tavern from her manumitted grandfather, Harry Compton. Put's was infamous for offering cockfights, gaming, and prostitution to a mixed-race crowd. As the mountain was steadily cleared and developed, new neighbors found Old Put's debauchery unappealing; in 1840, someone burned it down. Sylvia built an unusual new home on the property; it was a cedar structure resembling a wigwam. She bred prize hogs and lived in this structure until it too was torched around 1870. Disheartened, she moved in with her daughter. In 1883, Dr. Cornelius Larison penned her memoir in phonetic spelling, titled *Biografy of the Slav Who Whipt Her Mistres and Gand Her Fredom*. (Courtesy of the Hunterdon County Historical Society.)

Seventy members of the Rockefeller family, above, gathered for a two-day reunion in October 1906. The family was fêted at a banquet in Flemington where they heard a lecture titled "Our Rich Relations." Later the family climbed into 25 wagons and lumbered to Larison's Corner to view the 10-foot granite graveyard monument, pictured below, honoring Johann Peter Rockefeller, their first ancestor to settle in America. Johann Rockefeller owned a farm 1 mile west of Rocktown, and he is buried on a portion of that acreage. The Rockefellers toured where Johann lived and picked clean a pear tree supposedly planted by him. The most famous family member, John D. Rockefeller, did not attend. (Above photograph courtesy of the Hunterdon County Historical Society.)

Rockefeller Monument near Flemington, N. J.

The Washington Hotel, called Slater's Hotel in the 20th century, had rooms to let upstairs and a restaurant, bar, and pool hall downstairs. It was known as a wild place. Cornelius W. Larison rented a room there for three months and moved out because it was too raucous. Pictured here, two patrons enjoy the pool hall around 1910. (Courtesy of Betty Bollin.)

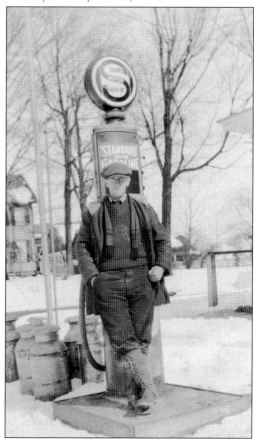

In this photograph, a man—possibly Ken Holcombe—leans against a gas pump on the busiest corner in Ringoes, in front of Elmer Holcombe's store. Not only was it the busiest store in town, they also pumped gas and collected milk, as shown here sometime in the 1920s or 1930s; the school bus picked up Ringoes children here as well. (Courtesy of Betty Bollin.)

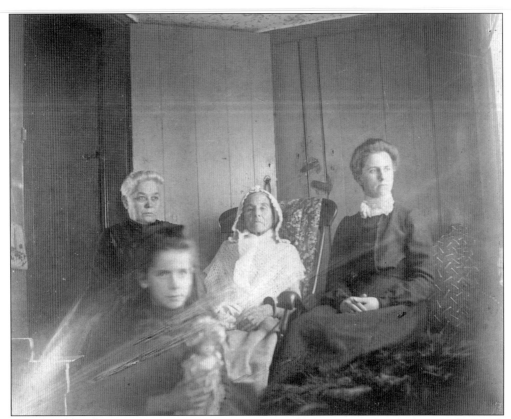

This photograph from 1910 shows four generations of the Strong family from Back Brook Road. On the left in front is Sarah Strong; in the back are, from left to right, her grandmother Lucretia Dilts, her great grandmother Narcissa Dilts, and her mother Laura Strong. (Courtesy of Ellen Ramberg.)

In this charming photograph taken around 1913, the Larison Church girls playfully pose on the wall of the Larison's Corner church cemetery. Shown are, from left to right, unidentified, Harrietta Brewer (Bateman), Anna Higgins (Bergen), Mary Brewer (Suydam), Sarah Strong, unidentified, and Jessie Fullerton. (Courtesy of Grace Cronce.)

Russell Fisher and Ada Holcombe are shown here on their wedding day in 1914 in front of the Fisher house in Ringoes. Russell graduated the year before from Lafayette College. After they were married, he commuted daily to New York City. (Courtesy of Charles Fisher.)

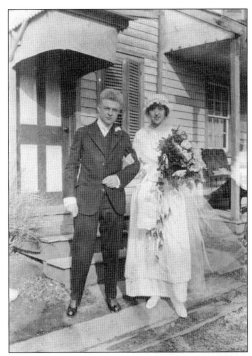

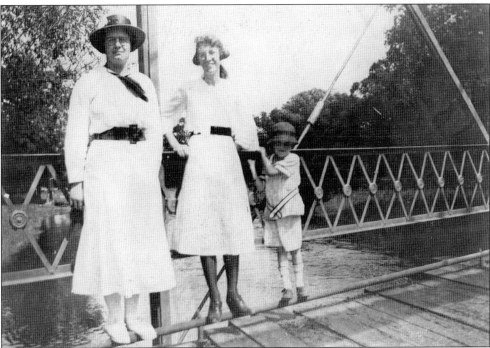

Myrtle Parks, Irvin Hockenbury's mother, is shown here enjoying the summer with her friend Miriam Case and her little brother Howard Parks on September 25, 1919. They are standing on a wooden bridge in Woodfern, just across the East Amwell–Hillsborough Township border near Neshanic Station. Howard went on to run the Hunterdon Theater in Flemington until it closed. (Courtesy of Irvin Hockenbury.)

Anton and Pauline Cvetan, shown here with their children Mary and Stephan, moved to East Amwell in 1926. Later they had twins named Joseph and Anthony. Stephan and Joseph eventually formed Cvetan Brothers produce. (Courtesy of Jani Collins.)

It takes planning—and water—to build a pond. In this photograph, Stephan Cvetan (left) and U.S. Soil Conservation agent Jesse Denton are laying out the farm pond on the Cvetan's Saddle Shop Road farm in 1960. (Courtesy of Jani Collins.)

Some families in East Amwell have been in the area since the early 1700s. The Sutphin family is one of the oldest Amwell families. Pictured to the right, local resident David Bond's great-grandmother Sutphin is pictured in front of her farmhouse on Dutch Lane in the late 1800s. Pictured below, Pauline Sutphin (Bond) holds her horse Fannie while her sister Kathryn and brother Milton sit in the buggy, in 1918. This photograph was also taken at the Sutphin farm on Dutch Lane, now owned by the Reiter family. (Both courtesy of David Bond.)

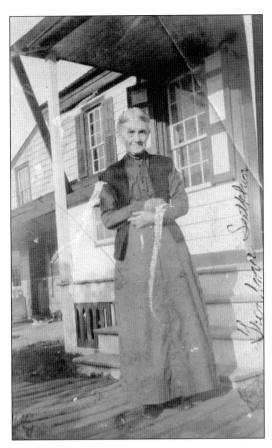

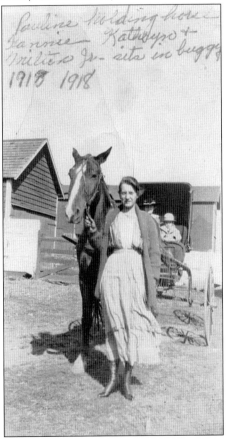

These high school chums all lived in Ringoes in the early 1930s. Pictured from left to right are (first row) Charles Fisher, Hiram Bellis, and Chester Wilson; (second row) Bessie Smith, Elizabeth Whittelsey, Margaret Higgins (Gritzmacher), Kathryn Stout, and Hilda Ruple. (Courtesy of Charles Fisher.)

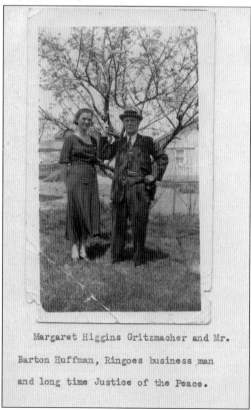

Margaret Higgins Gritzmacher and Mr. Barton Huffman, Ringoes business man and long time Justice of the Peace.

Neighbors in Ringoes, Margaret Higgins (Gritzmacher) and Bart Huffman chat over the fence line in this 1935 photograph. Margaret grew up living with her aunt, Rachel Berger, who was postmistress and operated the Ringoes post office out of their house. Later Margaret served as postmistress in the same house. Bart Huffman was the local justice of the peace.

As deer gradually returned to East Amwell, hunters came back, too. This picture from the early 1940s shows local hunters having successfully "driven" deer on Saddle Shop Road. Pictured are, from left to right, (first row) Earl Wilcox and Rodney Wilcox; (second row) unidentified, Eugene Brokaw, Harold Dally, and John Bollmer; (third row) T. "Red" Omdell, Steward Wilcox, Bill Cvecich, and unidentified. (Courtesy of Doris Wilcox.)

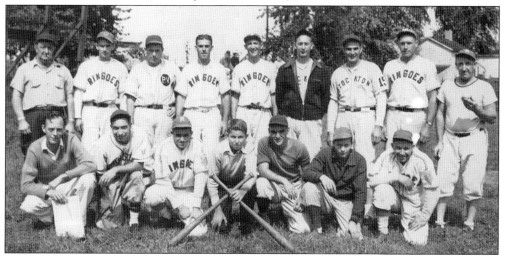

We are the champions! In 1941, Ringoes won the championship of the Delaware Valley Baseball League. Pictured above, order unknown, are D. Harrison (manager), P. Philhower, B. Conkling, W. Warwick, E. Turak, A. Hesse, W. Holcombe, W. Young, F. Wooden, A. Enard, S. Panicaro, P. Garboski, E. Lemore, L. Wooden, and G. Burenga. (Courtesy of William and Barbara Harrison.)

Above, maybe they did not rock 'n' roll all night and party every day, but Cathy, Justin, and Ronald Wielenta look like they are ready to put on an entertaining show. While in grammar school, the Wielenta brothers played in a band that performed on the Black River and Western Railroad. Pictured below, happy days are here again for Carl Hockenbury who is all grins and giggles on a sunny Reaville day in 1934. From the time when adults could hear the pounding of tiny bare feet past Ringoes Tavern to now when you can hear the swooshing of bicycles in Clawson Park, children have always been a source of joy and pride in East Amwell. (Above photograph courtesy of Ronald Wielenta; below photograph courtesy of Irvin Hockenbury.)

BIBLIOGRAPHY

Bond, Pauline Sutphen. *Life in Rural Ringoes: Recollections of Pauline Sutphen Bond 1900–1998.* Ringoes, NJ: The Amwell Heritage Society, 1999.

Boyer, Charles A. *Old Inns and Taverns of West Jersey.* Camden, NJ: Camden County Historical Society, 1962.

D'Autrechy, Phyllis B. *Hunterdon County Place Names.* Flemington, NJ: Hunterdon County Cultural and Heritage Commission, 1992.

East Amwell Bicentennial Committee. *A History of East Amwell, 1700–1800.* Flemington, NJ: Hunterdon County Historical Society, 1976.

Index of Revolutionary War Pension Applications in the National Archive. Vol. 2. Washington, D.C.: National Genealogical Society, 1976.

Olsen, Lora. *Movies Under the Stars: The Drive-in at Ringoes.* Ringoes, NJ: Self-published, 2004.

Quarrie, George. *Within a Jersey Circle: Tales of the Past.* Somerville, NJ: Unionist-Gazette Association Publishers, 1910.

Snell, James P. *History of Hunterdon and Somerset Counties, New Jersey, with Illustrations and Biographical Sketches of its Prominent Men and Pioneers.* Philadelphia, PA: Everts and Peck, 1881.

Van Sickle, Emogene. *The Old York Road and Its Stage Coach Days.* Somerville, NJ: Democrat Press, 1937.

www.arcadiapublishing.com

Discover books about the town where you grew up, the cities where your friends and families live, the town where your parents met, or even that retirement spot you've been dreaming about. Our Web site provides history lovers with exclusive deals, advanced notification about new titles, e-mail alerts of author events, and much more.

MADE IN THE USA

Arcadia Publishing, the leading local history publisher in the United States, is committed to making history accessible and meaningful through publishing books that celebrate and preserve the heritage of America's people and places. Consistent with our mission to preserve history on a local level, this book was printed in South Carolina on American-made paper and manufactured entirely in the United States.

This book carries the accredited Forest Stewardship Council (FSC) label and is printed on 100 percent FSC-certified paper. Products carrying the FSC label are independently certified to assure consumers that they come from forests that are managed to meet the social, economic, and ecological needs of present and future generations.

FSC
Mixed Sources
Product group from well-managed forests and other controlled sources

Cert no. SW-COC-001530
www.fsc.org
© 1996 Forest Stewardship Council

Find Your Place in History.